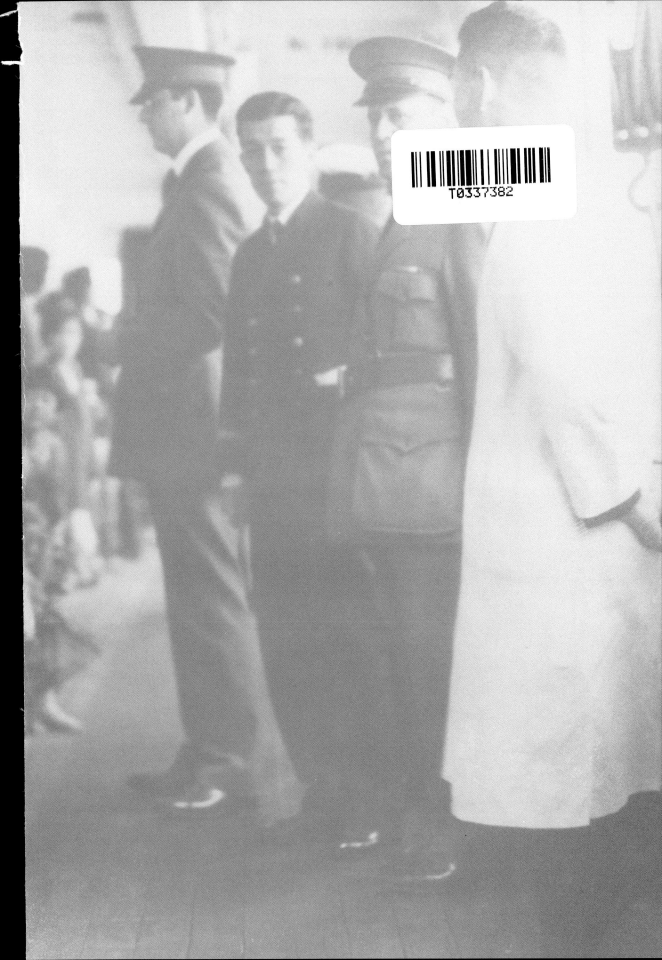

Attachments
Faces and Stories from America's Gates

By
Bruce I. Bustard

With a message from
David S. Ferriero
Archivist of the United States

The Foundation for the National Archives, Washington, DC
in Association with D Giles Limited, London

Attachments: Faces and Stories from America's Gates

This book is based on the National Archives Experience exhibition "Attachments: Faces and Stories from America's Gates," presented in the Lawrence F. O'Brien Gallery at the National Archives Building, Washington, DC, from June 15, 2012, to September 4, 2012.

Written by Bruce I. Bustard
Designed by Brian Barth
Edited by Patty Reinert Mason and Benjamin Guterman

For the Foundation for the National Archives
Thora Colot, Executive Director
Patty Reinert Mason, Director of Publications
Kathleen Lietzau, Publications and Research Assistant

For the National Archives and Records Administration
James Gardner, Executive for Legislative Archives, Presidential Libraries, and Museum Services
Marvin Pinkert, Director, Center for the National Archives Experience
Christina Rudy Smith, Director of Exhibits
Bruce I. Bustard, Curator
Ray Ruskin, Exhibit Designer
Brian Barth, Designer
Benjamin Guterman, Copyeditor

First published in 2012 by GILES
an imprint of D Giles Limited
4 Crescent Stables, 139 Upper Richmond Road
London, SW15 2TN, UK
www.gilesltd.com

ISBN (hardcover): 978-1-907804-07-6
ISBN (softcover): 978-0-9841033-5-5
Library of Congress Control Number: 2011942124

Front cover: **Deposition by Ngim Ah Oy (Lee Puey You) made at U.S. consulate, Hong Kong, March 17, 1939 (detail, see page 46)**
National Archives at San Francisco, Records of the Immigration and Naturalization Service

Inside front cover: **"Examining passengers aboard ships, vessel is the** ***Shinyo Maru,*** **" San Francisco, California, 1931**
National Archives, Records of the Public Health Service (90-G-152-2040)

Printed and bound in China

Attachments

Faces and Stories from America's Gates

By
Bruce I. Bustard

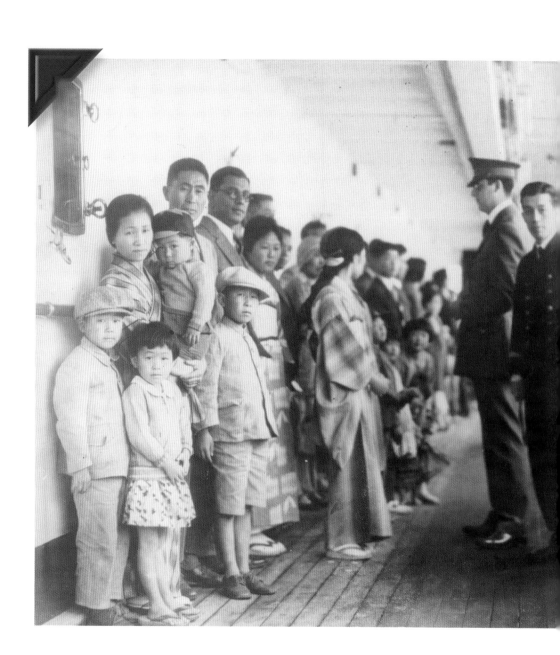

Contents

"Examining passengers aboard ships, vessel is the *Shinyo Maru*," San Francisco, California, 1931
National Archives, Records of the Public Health Service (90-G-152-2040)

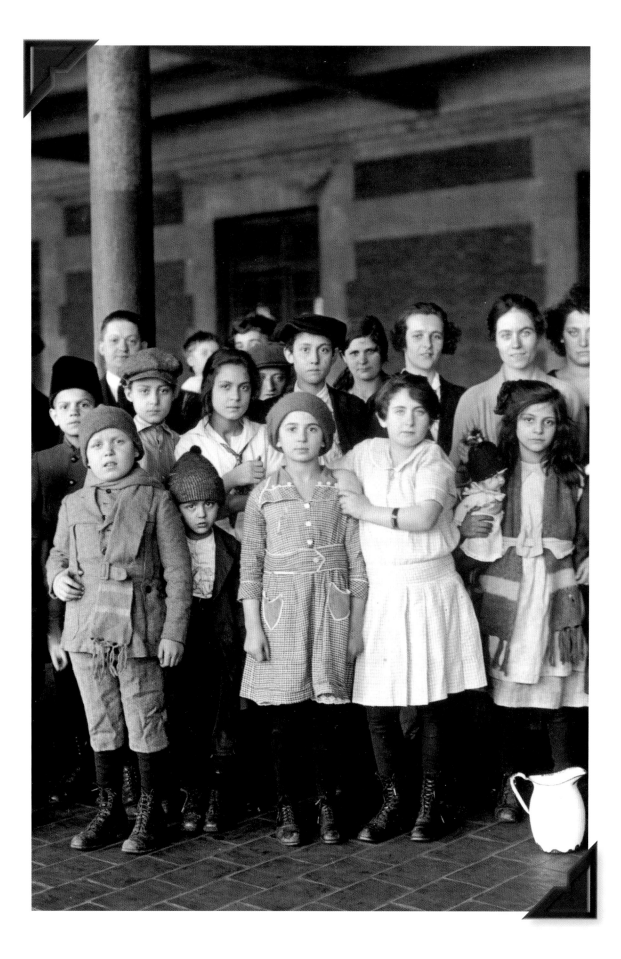

Message
from the Archivist of the United States

My grandfather, Paulo Ferriero, was 15 when he left his home in Melito Irpino, Italy, and sailed for America in 1903. My grandmother, Antoinetta Giorgio, followed 10 years later, aboard a ship named the *Romantic*.

When I discovered their names on the Boston passenger arrival lists, I was fascinated by all the pieces of their story I could string together—the names of their ships, what my grandfather was carrying in his pockets, and most importantly, who was coming to meet him. It turned out to be his father, who had arrived from Italy three years earlier. This was big news to me and to my family because we had always believed it was my grandparents who were the first from our family to come to the United States, where they would build a new life and a family that included my father and his 12 siblings.

Every small detail I could glean from the records led to another search. I pored over the records at Ellis Island, searched online through Ancestry.com, and consulted the experts at the National Archives. One day, I googled my grandparents' hometown in Italy and found a web site created by a geologist in the town, with pictures of Melito Irpino before and after the 1962 earthquake that had destroyed the old town and forced its people to relocate and rebuild nearby. I sent the webmaster an e-mail, and within 30 minutes I was connected with a Giorgio cousin.

By the time I could travel to Italy to meet him, my cousin had used the records in the Melito Irpino town hall to construct Ferriero and Giorgio family trees for me, back to the 1700s. I wandered the streets of the shattered old town and discovered the shell of an old church. There on the façade were the names of people who had moved far away, but sent money back to build the church. Among them were my ancestors, both families represented. It was a wonderful moment of surprise, pride, and deep emotion—a connection with my past. Like so

Opposite: Immigrant children at Ellis Island, New York, New York, ca. 1908 (detail) *National Archives, Records of the Public Health Service* (90-G-125-29)

many people featured in *Attachments: Faces and Stories from America's Gates*, my immigrant ancestors quickly attached themselves to America. Yet here was the evidence that they never lost their attachment to their homeland.

I hope the stories in this exhibition and its accompanying catalog will inspire you to explore your own family history at the National Archives. Perhaps you will find the name of a ship that brought your family here, a record of their arrival, maybe even a photograph. These threads of our immigrant past are among the billions of government records the National Archives holds in trust for the American people, but you are the researchers who bring them to life. I invite you to get started!

David S. Ferriero

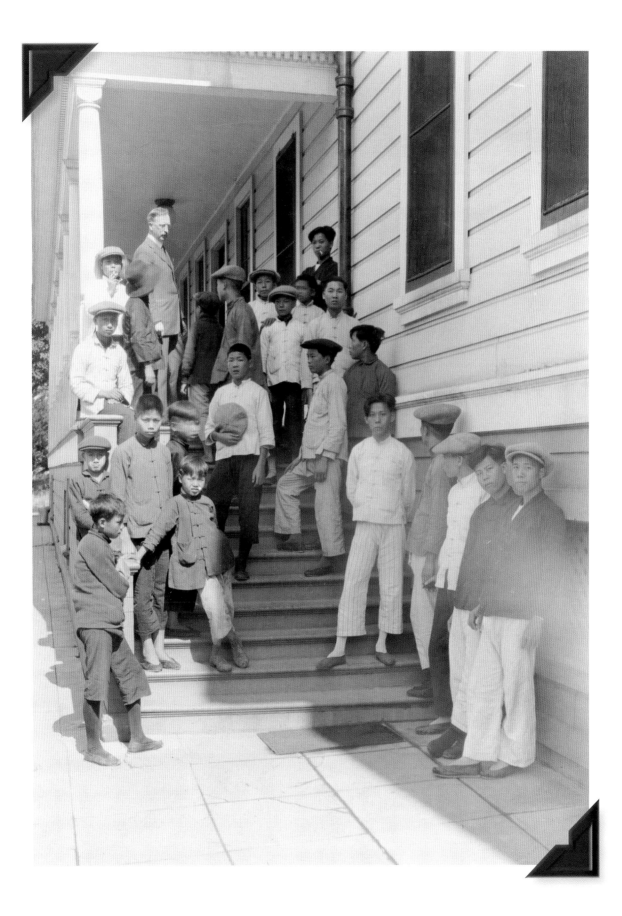

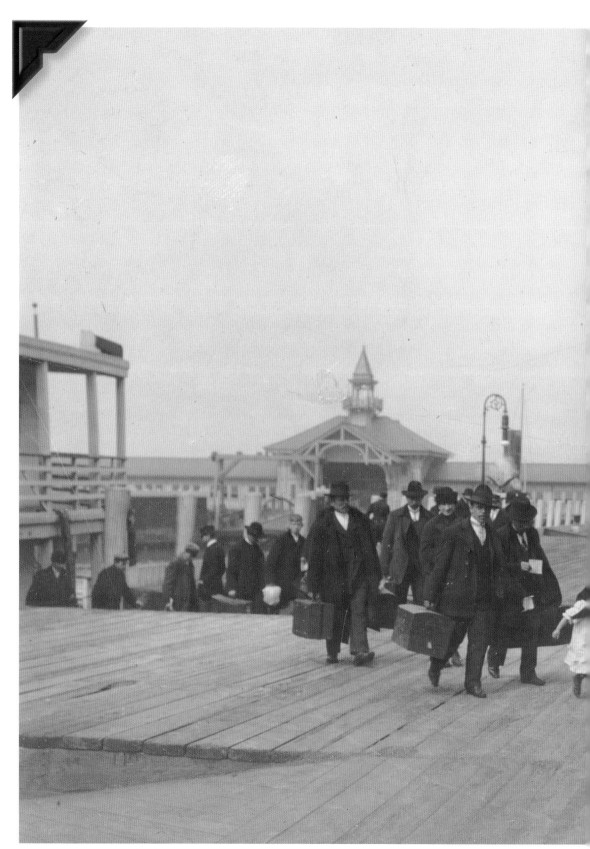

Immigrants landing at Ellis Island, ca. 1905
National Archives, Records of the Public Health Service (90-G-22D-42)

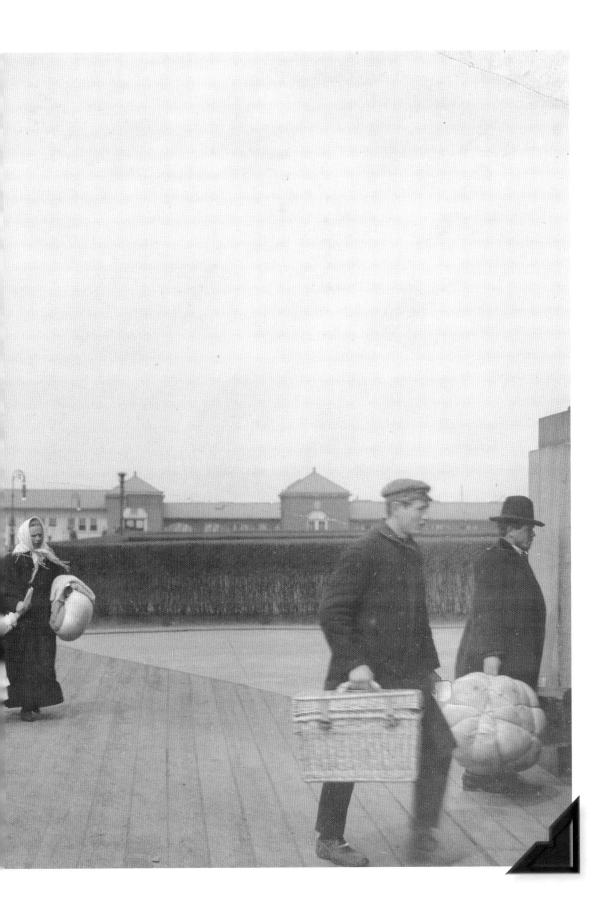

El Gobernador de la Provincia de Barcelona

SEÑAS PERSONALES

Estatura — *alta*
Frente — *regular*
Ojos — *pardos*
Boca — *regular*
Cabellos — *castaños*
Cejas — *idem*
Nariz — *regular*
Barba — *afeitada*
Bigote — *idem*
Piel — *color sano*
Contornos { Mentón / Pómulos
Signos particulares —

ACREDITA ante las Autoridades y Representantes diplomáticos y consulares de España en *los Estados Unidos de Norte America* como SÚBDITO ESPAÑOL a D. *José Oliver Oliver* nacido el *2* de *Septiembre* de *1888* en *Barcelona* provincia de *idem* cuyas señas personales, fotografía (sellada en su mitad), firma, impresión y fórmula dactilar constan en este documento; y hace constar que la nacionalidad española del mismo es *de origen; habita en Barcelona calle Salmeron nº 105.*

El interesado se propone ir a *Nueva York y Filipinas (EE. UU. N.A.)* con objeto de *asuntos comerciales* y el que suscribe ruega y encarga que a la presentación de este pasaporte, que deberá ser visado por *el Consul* de *los EEUU. N.A.* se otorguen y dispensen al acreditado las consideraciones y facilidades que pudiera necesitar.

Barcelona *8* de *Enero* de *1918.*

El Gobernador,

El Marques de Pilares

Firma del interesado

Por gastos de material y expedición UNA peseta. — Art.º 14 R. D. 12 Marzo 1917

(Véase al dorso)

Introduction

Attachments: Faces and Stories from America's Gates

Ne came with plenty of money; another carried only a handful of belongings. One was a visitor; another was a citizen returning home. One had her papers in order; another brought false documents, hoping to find a new life.

All of these men, women, and children left likenesses and traces of their journeys to America's entryways. Entering, leaving, or staying in America—their stories were captured in documents and photographs that were attached to government forms. *Attachments: Faces and Stories from America's Gates* draws from the millions of immigration case files in the National Archives to tell a few of these stories from the 1880s through World War II. It also explores the attachment of immigrants to family and community, and the attachment of some Americans to their beliefs about immigrants and citizenship.

These are dramatic tales of joy and disappointment, opportunity and discrimination, deceit and honesty—brought home by looking into the eyes of the immigrant. Each individual had his or her own personal reasons for coming to America. It might have been a desire to marry and start a family, to open a business, to make money, to educate children, or to escape persecution. But while motivations varied, the accounts that make up this book—and the exhibition upon which it was based— were driven by more than just individual circumstances. All of the people featured here were part of a vast worldwide migration that began in the 19th century and continued through the 20th. As economies were transformed by industrial capitalism, and as war, revolutions, and famine disrupted settled societies, more people were driven from their homes or chose to take advantage of more accessible and cheaper travel to move. This traffic went in many directions around the world, and those who participated could be merely sojourners or permanent settlers.

Early in American history, there were few laws about who could enter the United States, and the states controlled immigration. That changed after the Civil War when a series of Supreme Court rulings

Opposite: "El Gobernador de la Provincia de Barcelona" [Spanish passport for José Oliver], January 8, 1918
National Archives, Records of the Immigration and Naturalization Service

gave responsibility for immigration to the Federal Government. As millions of people from around the world poured into the United States, the Federal Government passed laws, approved processes, and built organizations to sift "desirable" from "undesirable" immigrants. Laws such as the Page Act (1875), the Chinese Exclusion Act (1882), and the National Origins Act (1924) limited who could enter by nationality and race. Federal agencies and organizations such as the State Department, Bureau of Immigration, and Border Patrol enforced these laws. The Government also built immigration processing and detention stations—most famously on Ellis Island, in New York Harbor, and on Angel Island, near San Francisco, California.

By the late 19th century, powerful anti-immigrant movements were pushing for restrictions based on national origin, as well as health, literacy, and political views. Fear of job competition and racism made Chinese immigrants the focus of this hostility, especially in the West, and led to the exclusion of almost all Chinese in 1882. Restriction was eventually extended to all Asian groups. In 1924, the National Origins Act imposed numerical limits by nationality, except for countries in the Western Hemisphere. Basing those limits on the 1890 census—which recorded a higher percentage of decendents from Western Europe—rather than the 1910 census led to lower numbers of Southern and Eastern European immigrants coming to America.

As U.S. immigration policies became more restrictive, photography—still a young art—held promise as a way for officials to identify and distinguish among travelers and to prevent illegal entry. Chinese immigrants were the first racial or ethnic group, and for years the only one, to be extensively documented by the camera. After the passage of the 1875 Page Act, a Chinese woman who traveled to the United States carried a photographic identity certificate from the Chinese Government that was inspected when she arrived. Under the authority of the 1882 Chinese Exclusion Act, Chinese who sought entry to the United States were issued certificates with detailed descriptions and, often, photographs. An 1893 amendment to the act specified for the first time that all Chinese entering the country required photographs for identity purposes. Later, Japanese immigrants also brought photo passports issued by the Japanese Government. And Chinese American citizens were required to submit photographs when they traveled abroad to ease their reentry to the United States.

Non-Asian immigrants were rarely photographed for identity purposes until America's entry into World War I raised worries about internal security and espionage. Wartime and postwar immigration laws restricting the numbers of immigrants who could come to the United States created an additional need to identify who could legally enter. Those papers, which often contained identity photographs, became increasingly standardized and, by the 1920s, were essential for legally entering or reentering, holding a job, proving citizenship, and staying in the United States. They were also essential to the Government's efforts to build a "paper wall" that would help control immigration and secure borders.

The title of this catalog and the exhibition that it accompanies uses the metaphor of "America's gates" as a way of capturing the moment when an individual's dream became a reality or was denied. But the faces and documents in this book also make a larger point. As Americans, we are proud to be a nation of immigrants where, in the words of Emma Lazarus's famous poem, the world's "tired," "poor," and "huddled masses yearning to breathe free" are welcomed and given the opportunity for liberty and a fresh start. There is certainly truth behind this belief. Millions who arrived at America's gates—including my Scottish and

German ancestors—walked through quickly and went on to build families and prosperous lives, if not for themselves, then for their children and grandchildren. Much of America's tradition of pluralism and tolerance has been shaped and encouraged by the successive streams of immigrants who have arrived, and continue to arrive, here. The documents reproduced in this book highlight inspiring acts of personal courage, tenacity, and hope.

But America's "immigrant story" has always been much more complicated than ideals and poetry. The records in *Attachments* reveal that the answer to the question of who could pass through America's gates and be allowed to join—or rejoin—our national community depended, by law, on such factors as a person's land of origin, race, and gender, and when and where he

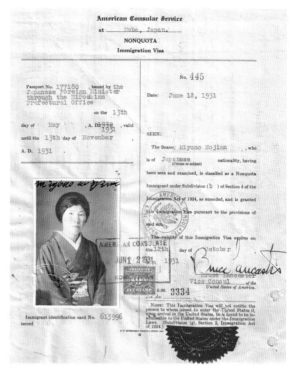

"American Consular Service at Kobe, Japan NonQuota Immigration Visa" for Miyono Nojima, June 12, 1931. *National Archives at San Francisco, Records of the Immigration and Naturalization Service*

or she tried to enter. When Chun Sik On arrived in San Francisco in 1883, he had to bring a certificate proving he was an exception to the general ban on Chinese entering the country under the new Chinese Exclusion Act. Mary Yee, a white woman born in Michigan, "became" Chinese in the eyes of the law when she married Yee Shing and had to certify her right to return to the United States using a form designed for a "lawfully domiciled Chinese Laborer." Richard Arvay, a refugee from Nazi Germany, benefited from a brief relaxation in immigration regulations that allowed him to come to the United States during World War II.

All these details—the inspiring and uplifting as well as the mundane and heartbreaking—are recorded in the documents and photographs presented here. After their usefulness to the Federal agency that created them had passed, the original forms, memos, photographs, and letters that make up millions of case files came to the National Archives, where they are now accessible to any interested researcher, from the family history dabbler to the most distinguished scholar. As such, the documents themselves represent a kind of gateway—a gateway to America's immigrant past and a gateway to understanding its complexity.

Bruce I. Bustard

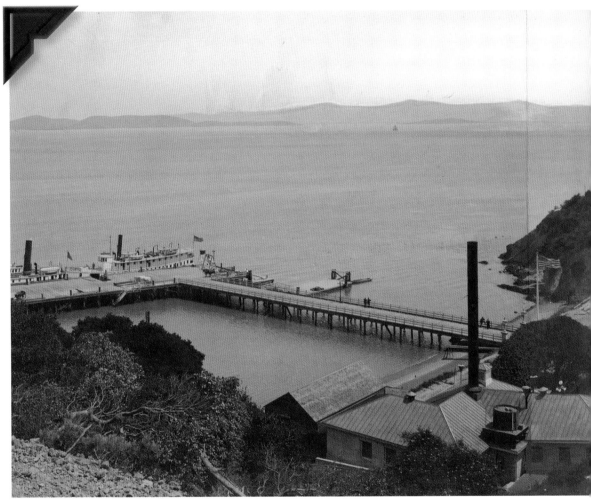

Angel Island Immigration Station, San Francisco, California, ca. 1910 (detail)
National Archives, Records of the Immigration and Naturalization Service

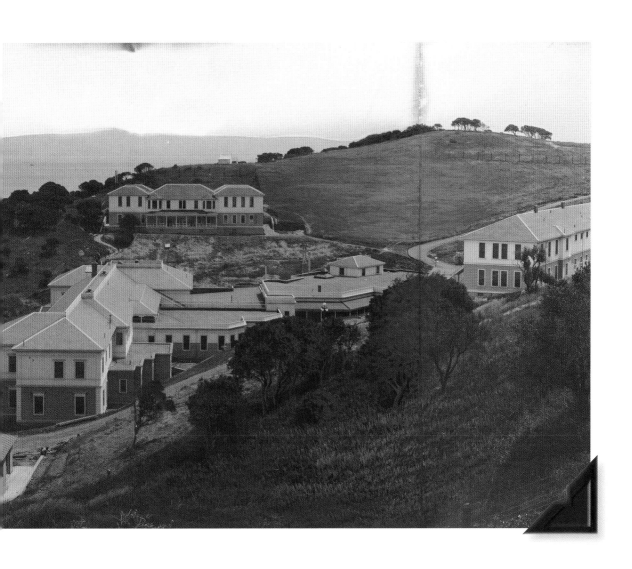

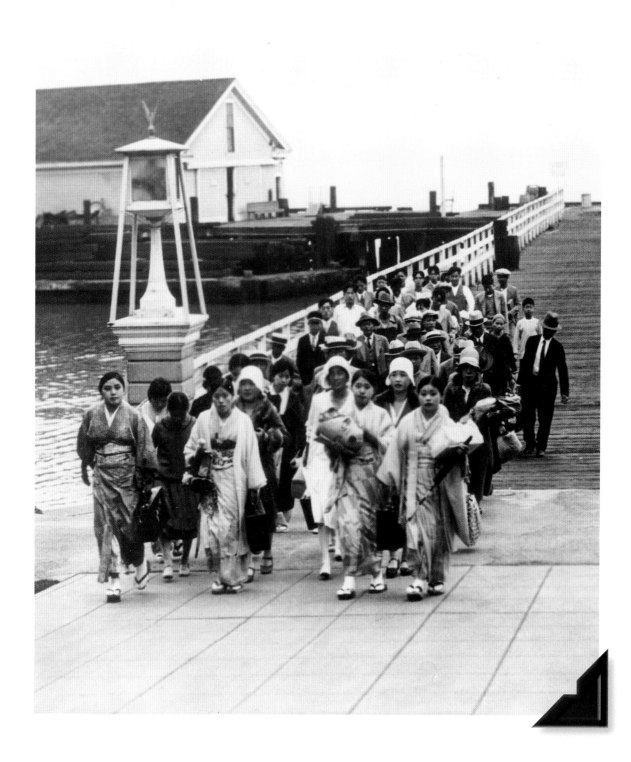

Entering

For an immigrant, entering the United States was exciting, strange, and frightening, but for the great majority the process was over quickly and successfully. On Ellis Island, most stayed only a few hours. Even on Angel Island, which was built to isolate and detain Chinese, most non-Chinese stayed only a few days, while most Chinese stayed two or three weeks. Still, the stakes were high. Entering America meant being able to join a spouse or parent; it meant a chance to marry, start a business, pursue an education, and bring family members to the United States. For U.S.-born Asian Americans returning to their country after traveling abroad, it was a test of their citizenship. For those escaping religious or political persecution, the outcome of their immigration application could mean life or death.

High stakes led some individuals to take desperate measures. Some used forged visas and other forms; others created false families or crossed borders illegally. Many appealed detention or fought deportation in the courts.

Opposite: **Immigrants arriving at Angel Island, 1931 (detail)** *National Archives, Records of the Public Health Service* (90-G-152-2038)

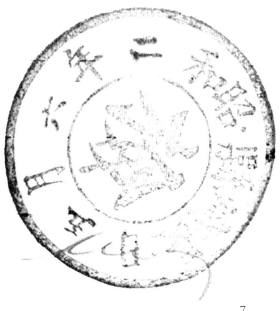

Chun Sik On

"to come and go of his own free will . . ."

Opposite: Section 6
certificate for
Chun Sik On,
October 26, 1883
*National Archives at San
Francisco, Records of District
Courts of the United States*

When the Chinese Exclusion Act became law in 1882, U.S. Customs agents, who were then in charge of immigration, scrambled to enforce it. The new law stipulated that most Chinese were barred from entering the United States. Exceptions—diplomats, merchants, students, tourists, and missionaries—would have to be sorted from those who were prevented from entering.

Chun Sik On arrived in San Francisco in December of 1883, one of 364 Chinese passengers on board the SS *Oceanic*. Described as a "trader," he brought with him a Section 6 certificate. These large, impressive documents were issued by the Chinese Government, printed in Chinese and English, and contained a photograph of the bearer. The certificate served as an identity document and as proof that the individual fell into one of the exempt classes and should therefore be allowed "to come and go of his own free will."

Initially, Chun was denied entry, but like dozens of other Chinese passengers aboard the *Oceanic*, he challenged his detention, asking a U.S. court to issue a writ of habeas corpus—a demand to show why he was being held and to ask for his release.

Chun's tactic was successful. He was allowed in on March 12, 1884, several months after his ship arrived. But in 1905, habeas corpus—the legal avenue that had brought Chun and many other Chinese ashore—became more difficult when the Supreme Court ruled that immigration processing was an administrative matter and that inspectors, not courts, would usually have the final word on who would enter.

343

No. 968.

DEPARTMENT OF HIS IMPERIAL CHINESE MAJESTY'S
SUPERINTENDENT OF CUSTOMS.

Canton, 26th October 1883.

I, the undersigned, His Imperial Chinese Majesty's Superinten-dent of Customs in the Kwang-tung Province, hereby certify that *Chun Sik On*, a subject of the Empire of China, to whom this certificate is issued, is entitled under the provisions of the Treaty of the sixth year of the Emperor Kwang-Sü, i.e. 1880 between China and the United States, to go and come of his free will and accord to the United States on the presentation of the same to the Collector of Customs of the American port at which he shall arrive.

The required description of his person follows :—

NAME.	AGE.	OCCUPATION.
Chun Sik On.	*Eighteen.*	*Trader.*

RESIDENCE.	HEIGHT.	COMPLEXION.
Nan-hai District.	*Five ft. seven ins.*	*Dark.*

COLOUR OF EYES.	PHYSICAL PECULIARITIES.	OFFICIAL TITLE.
Black.		*None.*

崇 (*Chung*)

SUPERINTENDENT OF CUSTOMS.

席 寶 書

Chung Sik
Oceanic
Med 12 '84 per Deputy
Discharged
Med 14/8/ (Shu Pan Shoo)

Ng Ah Tye
"a native born citizen of the United States"

Opposite and below:
Passport application for Ng Ah Tye and family, July 12, 1906
Ng Ah Tye's passport application includes photographs of him; his wife, Ng Lee Ting Tye; and their three children. Their sons were named after American industrialist Leland Stanford and English biologist and social philosopher Herbert Spencer, and their daughter Ng Van Gesner Tye after the physician who delivered her.
National Archives, Records of the Immigration and Naturalization Service

Ng Ah Tye was born in Prineville, Oregon, in 1871. By 1901, he had married Ng Lee Ting Tye, and was the father of three children. That year, he and his family left Oregon and traveled to Hong Kong for his job as a merchandise buyer. After living in Hong Kong for five years, Ng went to the American consulate and filled out an application for an "emergency passport" for himself and his family. Because he claimed to be an American citizen who was also Chinese, Ng had to go through several extraordinary steps. Unlike non-Chinese Americans, he not only filed an application but submitted copies of depositions from a variety of white witnesses, including the mayor of his hometown in Oregon, a county judge, the sheriff, and the postmaster, who all confirmed that Ng had been born in the United States. He also filed depositions by the physician who had delivered his children to prove their U.S. citizenship.

Ng secured his U.S. passport, and filed for renewal six more times between 1906 and 1921. It is unclear if Ng actually returned to the United States.

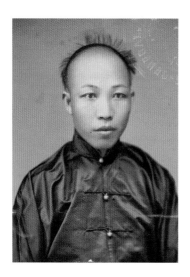
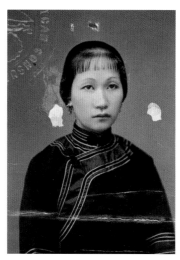
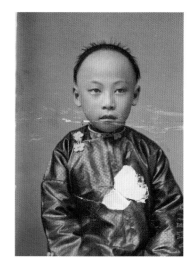

[Edition of 1889.]

(Form No. 176.)

Fee for Passport, - - - $1.00
Fee for filling out applica-
 tion in duplicate, - - .50
Fee for administering oath
 in duplicate, - - - - .50

NATIVE.

Issued, *July 12*, 190 6

Ng Ah Tye, a native and loyal citizen of the United

hereby apply to the *Consul General* of the United States at *Hongkong*

port for myself, accompanied by my wife *Ng Lee ting Tye*, and minor

as follows: *Ng Leland Stanford Tye*, born at *Prineville Oregon*

26 day of *November*, 1897, and *Ng Van Grener Tye*

July 10 1899 at Prineville and Ng Herbert

Greer Tye, at Prineville Oregon Apl 28. 1901

I solemnly swear that I was born at *Portland*, in the State

of *Oregon*, on or about the *14* day of *May*, 18 71

that *and grandfather went to many years ago* citizen of the United States; that I am domiciled in the

United States, my permanent residence being at *Prineville*, in the

State of *Oregon*, where I follow the occupation of *General Merchandise*

that I left the United States on the *2* day of *November*, 190 1 and am now

temporarily sojourning at *Hongkong 10 DesVoeux Road*, that I am the bearer of

Travel Passport No. *186*, issued by *Robt M. McWade* on the *4* day

of *May*, 190 4; that I intend to return to the United States within

two with the purpose of residing and performing the duties of citizen-

ship therein; and that I desire the passport for the purpose of *making a home*

in the U.S. for the Education of my children.

OATH OF ALLEGIANCE.

Further, I do solemnly swear that I will support and defend the Constitution of the United
States against all enemies, foreign and domestic; that I will bear true faith and allegiance to
the same; and that I take this obligation freely, without any mental reservation or purpose of
evasion: So help me God.

× *Ng Ah Tye*

Consulate General OF THE UNITED STATES AT *Hongkong*

Sworn to before me, this *12* day of *July*, 190 6

Age: *35* years.
Stature: *5* fe
Forehead: *Var*
Eyes: *dark*
Nose: *Quit*

I hereby certify tha

personally, and know h

stated in h affidavi

AMERICAN
CONSULAR SERVICE
$1
FEE STAMP
1906

form is to be filled
the quarterly returns to the Departm

Emile and Rose Louis
"for us to be deported . . . would mean starvation"

Opposite: "Declaration of Alien About to Depart for the United States," January 24, 1918
National Archives at San Francisco, Records of the Immigration and Naturalization Service

Opposite, inset: Letter from Rose Louis to "Dear Sir," April 10, 1918
National Archives at San Francisco, Records of the Immigration and Naturalization Service

Below: Rose and Emile Louis (attached on page 2 of "Declaration")
National Archives at San Francisco, Records of the Immigration and Naturalization Service

Emile and Rose Louis traveled to the United States but had no intention of staying here. The married couple, British citizens who worked as ship stewards, arrived in San Francisco from Hong Kong with their seven-week-old son in February 1918. They planned to travel through the United States to Vancouver, British Columbia, where they expected to find work. But immigration inspectors on Angel Island had several problems with landing them. Fifty-five-year-old Emile was deemed illiterate, and the entire family was judged to be without any means of financial support. They were "likely to become a public charge," and Rose, despite her work history, was judged "entirely dependent" on Emile.

The family spent the next six months on Angel Island fighting deportation to Hong Kong. Rose wrote several letters pleading for permission to travel to Canada or for Emile to go to San Francisco to find work on a foreign-bound ship. To be sent back to Hong Kong, where the couple would be forced to compete with low-paid Chinese laborers, "would mean starvation," she wrote.

The Immigration Service finally ruled that the Louis family could pass through the United States, but only if Canadian authorities agreed to accept them. No such assurances ever came, and the family was deported back to Hong Kong in July 1918.

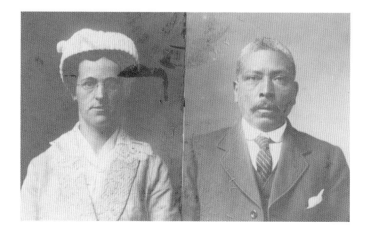

16919
5—1 to 3

(Form No. 228.)
(Established July, 1917.)

DECLARATION OF ALIEN ABOUT TO DEPART FOR THE UNITED STATES.

(See General Instruction No. 535.)

American Consulate General _____ Hongkong _____ 24th Jan 1918
(Title of office.) _____ (Place.) _____ (Date.)

I, _Emile Louis_____, _Ship Steward_, a CITIZEN OR SUBJECT OF

_Great Britain_____, bearer of passport No. _548_, dated _Jan 22—1918_
(Name of country.)

issued by _Governor Hongkong_ am about to go to the United States, accompanied by
(Name of office.)

Wife, _Rose Louis_____, born at _____ Liverpool _____
(Full name.)

Sons under 16 years of age as follows :

_Thomas Alfred_____, born at _Hongkong_____ 13th Dec 191?.
(Name.) _____ (Date.)

_____, born at _____,

And daughters under 21 years of age as follows :

_____, born at _____,
(Name.) _____ (Date.)

_____, born at _____ Nov 16. 1862.

1. I was born at _Port Louis Mauritius_____ on _Nov 16. 1862_
(Place.) _____ (Date.)

2. My father was a citizen or subject of _Great Britain_, of the _Mauritius_
race ; my mother was born a citizen or subject of _Great Britain_ of the
Mauritius race ;

3. (a) I last resided at _Liverpool_, 99 _Northumberland_ on _April 1917_.
(Place) _____ (Address.) Terrace _____ (Dates.)

(b) I have resided in or visited the following countries within the past five years :—
(Places, addresses, and dates.)
Sailing as steward, various countries visited ;

4. I have _Never_ previously resided in the United States as follows :
(Dates.) _____ (Place and address.)

5. I intend to depart for the United States on the date, from
25th January 1918 _Hongkong_
(Date.) _____ (Port.)

6. I name the following, with addresses, as references :
(a) _Captain Bexler_ _____
(In the country from which)

(b) _None_ _____
(In the United)

10/4/1918 Angel Island
Immigration Station

Dear Sir

As a last resource I appeal to
you as I have appealed to the British
Consul & herewith enclose reply received
could you not land My Husband &
self on Parole until such times as
we could return to England as he
would certainly obtain work on one
of the coasting steamers & for us to
be deported to Hong Kong would
mean starvation as it is all
Chinese Labour in that Port
Trusting you will consider
the matter for the sake of My
Baby I am
Dear Sir
Yours Respectfully
Rose. Louis

American Consular Service

at......Warsaw.......Poland.......

QUOTA
Immigration Visa

* Nonpreference ☒

Preference ☐

Passport No. 23430 , issued by
1442/23

Starostwo

Wilno Poland on the 12th

day of **Aug.** , A. D. 1923 , valid

until the 2ₚ day of **Aug.**

A. D. 1924 .

No. 125

Polish Polish
(Quota.) (Nationality.)

Date: **Aug. IIth 1924**

SEEN:

The Bearer, **Elstein Chlewne** , who

is of **Polish** nationality, having
(Citizen or subject.)

been seen and examined, is classified as a Quota Immi-

grant and is granted this Immigration Visa, pursuant

to the Immigration Act of 1924.

The validity of this Immigration Visa expires on

the **IIth** day of **DEC.**

1924
A. D.

[signature]
Vice Consul of the
United States of America.

[American Consular Service $9 Fee Stamp]

Fee $9.00
Fee No. 946

NOTE: This Immigration Visa will not entitle the
person to whom issued to enter the United States if,
upon arrival in the United States, he is found to be in-
admissible to the United States under the Immigration
Laws. (Subdivision (g), Section 2, Immigration Act
of 1924.)
* Check appropriate classification.

[signature]

Elstein Chlewne
"Quota Immigration Visa"

Elstein Chlewne was one of 31 prospective Polish immigrants who tried to travel together to the United States in September 1924. The group's chance of success had diminished because of a new U.S. law that took effect a few months earlier. The National Origins Act created annual "quotas"— numerical limits—that significantly reduced the number of immigrants who could come into the United States from countries in Eastern and Southern Europe.

Chlewne and his fellow Poles turned to an immigrant smuggler who provided them with forged documents said to have been issued at the American consulate in Warsaw. The group left Poland for Paris, where they picked up their false papers. They then went on to Antwerp, Belgium, where they planned to board a ship for England and sail to the United States. Steamship employees in Antwerp became suspicious and, fearing they could be fined if they carried inadmissible immigrants to the United States, alerted the U.S. consulate. The Polish immigrants' visas were confiscated, and the State Department established that the papers were forgeries.

Chlewne and the other 30 would-be Americans were returned to Poland. His forged visa and birth certificate became part of an Immigration Service file dealing with illegal immigration from Eastern Europe.

Opposite: *"Quota Immigration Visa" for Elstein Chlewne, August 11, 1924* Immigration officials spotted problems with the stamps and seals and found several misspellings on the visa, which led them to conclude it was a forgery. *National Archives, Records of the Immigration and Naturalization Service*

Below: *Polish birth certificate for Elstein Chlewne, 1924 National Archives, Records of the Immigration and Naturalization Service*

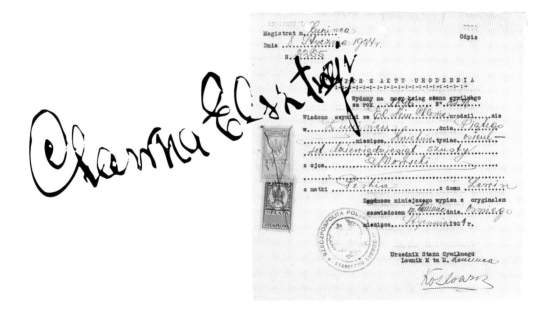

Pasquale Taraffo
"Paganini of the guitar"

Pasquale Taraffo, like many who came through America's gates, was only visiting. He was born in Genoa, Italy, in 1887. Pasquale learned to play the guitar as a child and began giving concerts at the age of nine, eventually switching from the traditional guitar to the harp guitar—an enormous 14-stringed instrument mounted on a pedestal. By the early 20th century he was touring Italy, and in 1910, made the first of several successful concert tours abroad. Taraffo's tours, especially of South America, were wildly popular, and he was critically acclaimed as "the Paganini of the guitar"—a reference to the legendary Italian violinist Niccolò Paganini.

A handbill for his 1926 concert in Correggio, Italy, along with photo-postcards of him with his harp guitar, were found in an Immigration Bureau file that dates from the late 1920s. The file, which also contains passports, birth certificates, marriage licenses, and baptismal certificates for a variety of individuals, appears to be a dead letter file holding documents that have no accompanying communication or that could not be returned to the owner. Taraffo came to the United States three times—once for a concert tour of New York City and California in 1928–29, as a crew member on a ship that docked in New York in 1933, and for a brief concert stop in New York in 1935. As a person applying for a visa based on his artistic abilities, he had to submit evidence of his exceptional talent. It may be that those documents became separated from others in his file.

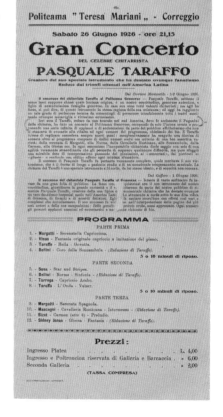

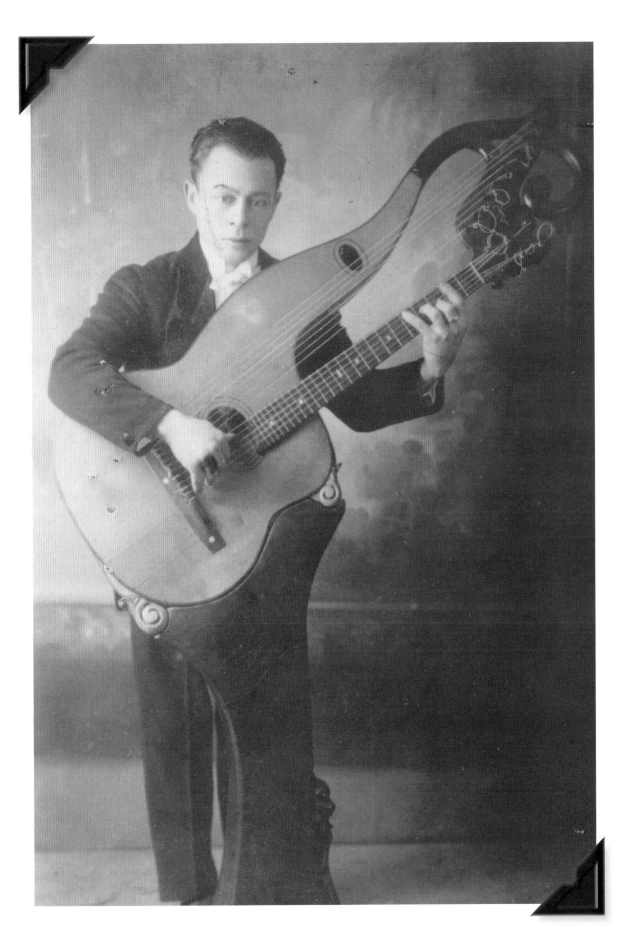

Wong Lan Fong
"wife of a lawfully domiciled treaty merchant"

Opposite: Wong Lan Fong

Below: Wedding photograph of Wong Lan Fong and Yee Shew Ning, 1926 (detail)
National Archives at San Francisco, Records of the Immigration and Naturalization Service

Chinese women immigrants faced not only racial prejudice but also false assumptions about their gender roles. The first anti-Chinese legislation enacted into American law—the 1875 Page Act—aimed to prevent not only Chinese contract workers but also Chinese prostitutes from entering the United States. The law reflected a popular American prejudice, lasting well into the 20th century, that most Chinese women were brought to America for prostitution.

When 27-year-old Wong Lan Fong and her new husband, Yee Shew Ning, traveled to the United States, they were aware of such prejudices and took measures to emphasize their respectability and economic status. They delayed their departure for the United States until they had enough money to travel in first class. They also submitted a letter from the clergyman who performed their wedding ceremony, attesting to their good character. Immigration officials seized further evidence when they confiscated the couple's wedding photograph as proof of their marriage. The couple's strategy worked. The two were detained on Angel Island only one day before being allowed to land.

Some 70 years later, their granddaughter, American historian Erika Lee, was conducting research for her book on Chinese immigration at the National Archives in San Bruno, California, when she discovered her grandparents' wedding photograph in her grandmother's immigration file.

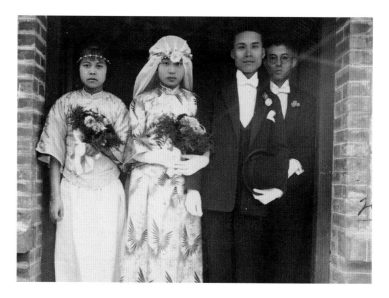

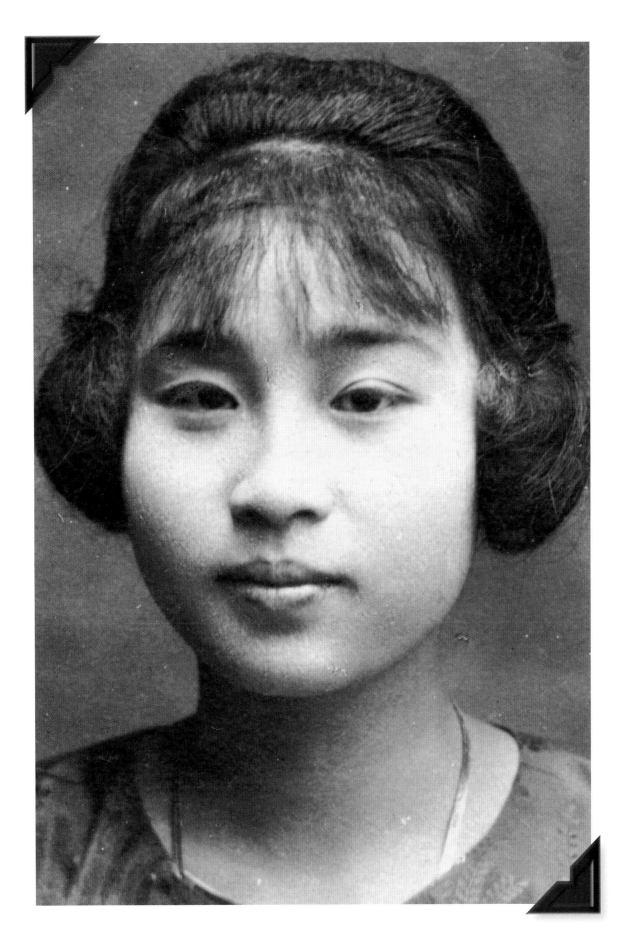

I have informed myself of the provisions of the Act of February 5, 1917, particularly of the exclusion provisions of Section 3 of that Act, and of the Immigration Act of 1924, and am aware that the latter provides:

"The admission to the United States of an alien excepted from the class of immigrants * * * * shall be for such time and under such conditions as may be by regulations prescribed, including, when deemed necessary, the giving of bond with sufficient security to insure that, at the expiration of such time or upon failure to maintain the status under which admitted, he will depart from the United States."

I realize that if I am not one of a class exempted from the provisions of any of the immigration laws of the United States regarding the exclusion of aliens, or if my classification as a non-immigrant alien is not approved upon arrival in the United States, I may be deported or detained by the immigration authorities in the United States, and I am prepared to assume the risk of deportation and of compulsory return.

I solemnly swear that the foregoing statements are true to the best of my knowledge and belief.

Wong Lan Fong 黄蘭芳
(Signature of declarant)

Subscribed and sworn to before me this ___27th___ day of ___April___, 192 7

James E. McKenna
JAMES E. MCKENNA
Consul ___ of the United States of America

[SEAL]

Fee No. 49-7
($1.00)
Passport Visa No. 43
($9.00)
Consul's findings of exempt status:

Passport Visa granted ___April 27___, 192 7
and the following notation placed on passport—
Visa granted as Non-immigrant under Section 3
(___6___) of the Act of 1924—

(Non-immigrant class)

Passport Visa refused ___, 192

Reasons:
American Consulate. No. **43**
at _Canton_ _China_
(City) (Country)
SEEN

For the journey to the United States,
via _San Francisco_

Douglas Jenkins
DOUGLAS JENKINS
(Consul General)

Date **April 27, 1927**

(The validity of this visa expires twelve months from this date, provided the passport itself continues to be valid for that period.)

Visa granted as
Non-Immigrant under
Section 3 (**6**) of the Act of 1924

(class) _Treaty of commerce_

Douglas Jenkins
DOUGLAS JENKINS
(Consul General)

Seal and
Fee Stamp

"Declaration of Non-immigrant Alien About to Depart for the United States," April 27, 1927, page 2
National Archives at San Francisco, Records of the Immigration and Naturalization Service

AMERICAN-CHINESE SCHOOL

廣州市美華崗美華學校

MEI WA KONG

CANTON, CHINA

February 23/27

To The Immigration
Officer, San Francisco,
Dear Sir:

The bearer of This letter is Mr. Yee Shew King.
He carries a marriage certificate which is signed
by me as The clergyman who performed The marriage
ceremony in The Chinese Methodist Church located
on The Island of Honam, which is across the
Pearl River from Canton City. The bride Wong
Lan Hong, her maiden name, is a member
in The United Brithren Mission of This city.

Mr. Yee carries a certificate showing that
he is a merchant in Buffalo, N.Y.. He is now
bringing his wife with him to The States. Kindly
assist him in landing, if This is within your
legal power —

Sincerely yours —

C. A. Nelson
Vice Principal of
The Am-Chinese School.

My Chinese name is
伍賴佶

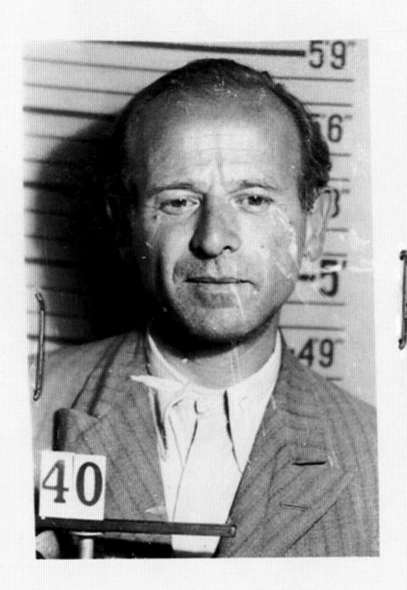

Richard Arvay

"I also would find it impossible to live in a country where all my family have been killed . . ."

After the Nazis came to power in Germany in 1933, many German and Austrian Jews tried to flee persecution. Although about 250,000 would successfully come to the United States between 1933 and 1945, State Department officials screened visa applicants so carefully, especially after the outbreak of World War II in 1939, that immigration quotas for Germany and Austria were rarely filled.

Richard Arvay was one of the few European Jews who managed to escape the Holocaust and come to the United States during the war. An Austrian, Arvay was a writer and filmmaker in the late 1920s and early 1930s. Having suffered persecution by the Nazis, he fled to Paris when Germany annexed Austria in 1938. After Germany occupied France in 1940, Arvay spent a year in a concentration camp. He then lived in southern France, and in 1943, escaped to Italy after he faced possible deportation to Poland and the Nazi death camps there.

In 1944, Arvay was one of about a thousand refugees picked to come to America to live in the newly established Fort Ontario Emergency Refugee Shelter in Oswego, New York. The camp had been established by President Franklin D. Roosevelt as a response to political pressures to do more to help Jews in Europe. Initially, refugees had to promise to return to Europe when the war was over; President Harry S. Truman later permitted the refugees to stay in the United States.

Richard Arvay lived at Fort Ontario for about 18 months. After the war, he brought his wife to America, settled in New York City, and worked as a writer. In 1951 he became a U.S. citizen. Arvay died in 1970.

Opposite: Richard Arvay, from his identification form completed at the Fort Ontario Emergency Refugee Shelter, July 1944
National Archives, Records of the War Relocation Authority

Below: Refugees registering at the Fort Ontario Emergency Refugee Camp, Oswego, New York, August 1944
Photograph by Hikaru Iwasaki
National Archives, Records of the War Relocation Authority (210-CFZ-28)

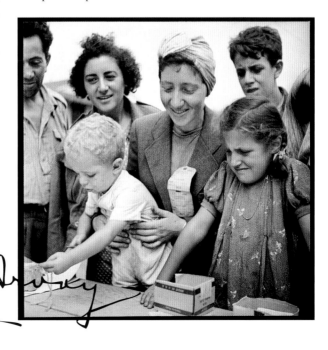

Above: **Handwritten note attached to Richard Arvay's background form, July 1944**

Richard Arvay's file includes his completed background form stating that he did not want to return to Europe. To his typed answers, Arvay added a handwritten explanation: "I also would find it impossible to live in a country where all my family have been killed."
National Archives, Records of the War Relocation Authority

Opposite: **Richard Arvay's "Declaration of Intention" for citizenship, June 14, 1946**
National Archives at New York City, Records of District Courts of the United States

TRIPLICATE
(To be given to declarant when originally issued; to be made a part of the petition for naturalization when petition is filed; and to be retained as a part of the petition in the records of the court)

UNITED STATES OF AMERICA

562286

DECLARATION OF INTENTION

No.

(Invalid for all purposes seven years after the date hereof)

STATE OF NEW YORK

SOUTHERN DISTRICT OF NEW YORK

In the DISTRICT Court

of UNITED STATES NEW YORK, N. Y. at

(1) My full, true, and correct name is RICHARD ARVAY also known as RICHARD ARVAI
(Full, true name, without abbreviation, and any other name which has been used, must appear here)

(2) My present place of residence is 123 West 93rd New York, N.Y.
(Number and street) (City or town) (County) (State)

(3) My occupation is writer (4) I am 49 years old. (5) I was born on March 13, 1897
(Month) (Day) (Year)

in Vienna, Austria
(City or town) (County, district, province, or state) (Country)

(6) My personal description is as follows: Sex male

color white complexion fair color of eyes color of hair blond height 5 feet 8 inches, weight 160 pounds,

visible distinctive marks none , race white , present nationality stateless

(7) I am married; the name of my wife or husband is Lea ; we were married on Feb. 27, 1937
(Month) (Day) (Year)

at Vienna, Austria ; he or she was born at Moscow, Russia
(City or town) (State or country) (City or town) (State, district, province, or state) (Country)

on May 11, 1904 and entered the United States at
(Month) (Day) (Year) (City or town) (State)

on for permanent residence in the United States and now resides at Paris, France
(Month) (Day) (Year) (City or town) (County and State)

(8) I have no children; and the name, sex, date and place of birth, and present place of residence of each of said children who is living, are as follows:

(9) My last place of foreign residence was Rome, Italy (10) I emigrated to the United States from
(City or town) (County, district, province, or state) (Country)

...... Niagara Falls, Canada
(City or town) (Country)

...... (11) My lawful entry for permanent residence in the United States was

at Niagara Falls, N.Y. under the name of Richard Arvay
(City or town) (State)

on February 3, 1946 on the SS "Rainbow Bridge"
(Month) (Day) (Year) (Name of vessel or other means of conveyance)

(12) Since my lawful entry for permanent residence I have not been absent from the United States, for a period or periods of 6 months or longer, as follows:

DEPARTED FROM THE UNITED STATES			RETURNED TO THE UNITED STATES		
PORT	DATE (Month, day, year)	VESSEL OR OTHER MEANS OF CONVEYANCE	PORT	DATE (Month, day, year)	VESSEL OR OTHER MEANS OF CONVEYANCE

(13) I have not heretofore made declaration of intention: No. , on at
(Month) (Day) (Year) (City or town)

...... in the
(County) (State) (Name of court)

(14) It is my intention in good faith to become a citizen of the United States and to reside permanently therein. (15) I will, before being admitted to citizenship, renounce absolutely and forever all allegiance and fidelity to any foreign prince, potentate, state, or sovereignty of whom or which at the time of admission to citizenship I may be a subject or citizen. (16) I am not an anarchist; nor a believer in the unlawful damage, injury, or destruction of property, or sabotage; nor a disbeliever in or opposed to organized government; nor a member of or affiliated with any organization or body of persons teaching disbelief in or opposition to organized government. (17) I certify that the photograph affixed to the duplicate and triplicate hereof is a likeness of me and was signed by me.

I do swear (affirm) that the statements I have made and the intentions I have expressed in this declaration of intention subscribed by me are true to the best of my knowledge and belief: SO HELP ME GOD.

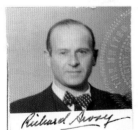

Richard Arvay

Richard Arvay
(Original and true signature of declarant without abbreviation, also other name if used)

Subscribed and sworn to (affirmed) before me in the form of oath shown above in the office of the

Clerk of said Court, at New York, N.Y.

this 14th day of June , anno Domini 19.. I hereby certify that

Certification No. 5300-L-14991 from the Commissioner of Immigration and Naturalization, showing the lawful entry for permanent residence of the declarant above named on the date stated in this declaration of intention, has been received by me, and that the photograph affixed to the duplicate and triplicate hereof is a likeness of the declarant.

[SEAL]

WILLIAM V. CONNELL U. S. DISTRICT Court

By Deputy Clerk.

Form N-315
U. S. DEPARTMENT OF JUSTICE
IMMIGRATION AND NATURALIZATION SERVICE
(Edition of 11-1-41)

e16—19119-1 U. S. GOVERNMENT PRINTING OFFICE

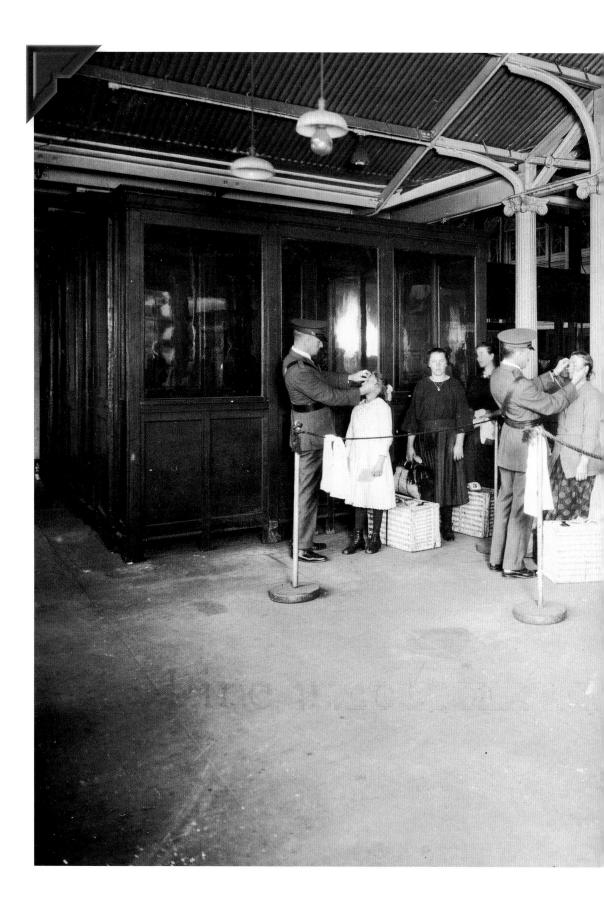

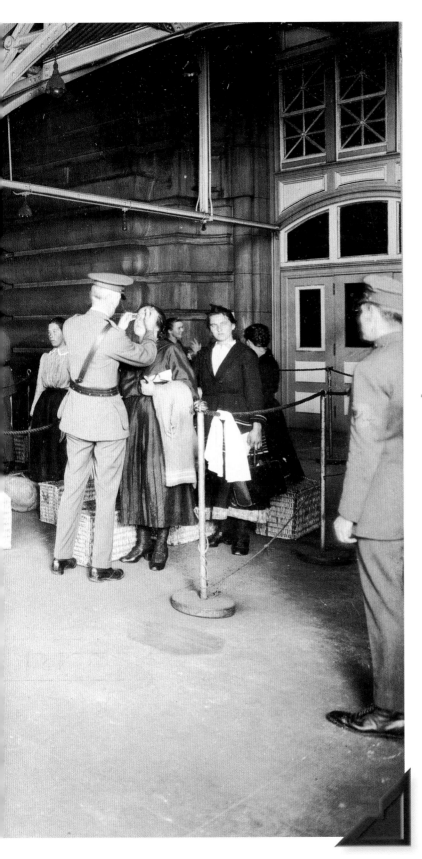

"Ellis Island, N.Y. Line inspection
of arriving aliens," 1923

*National Archives, Records of the
Public Health Service* (90-G-125-57)

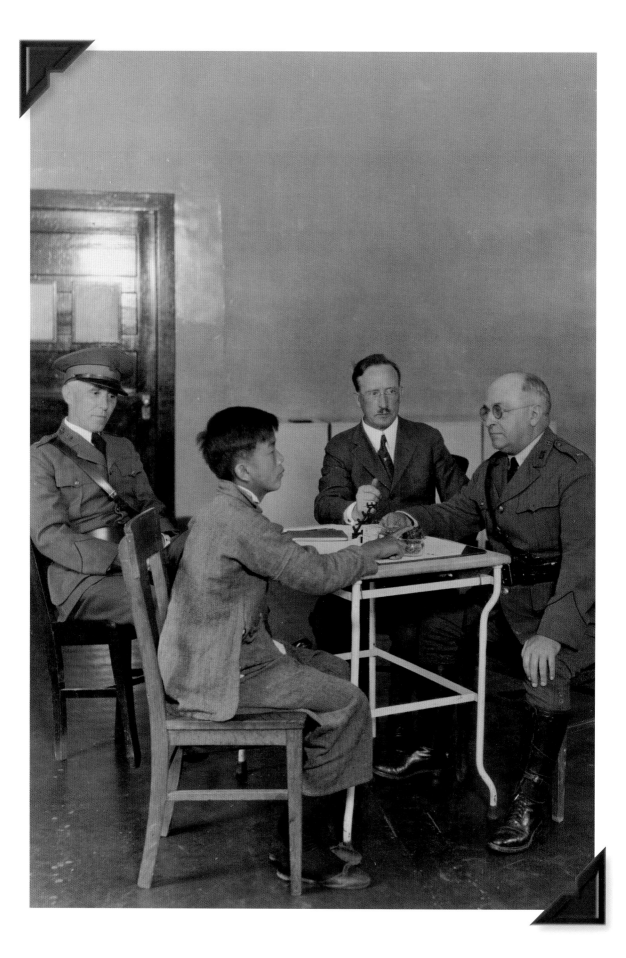

Leaving

Since its founding, Americans have seen their country as "a nation of immigrants"—a place to get a fresh start and make a new home. Millions who came here found freedom and opportunity, if not for themselves, then for their children and grandchildren. But others who came to America's gates could not enter, and some who entered later decided to return or were sent home.

For some, leaving was part of their original plan to make money on a temporary sojourn or to simply visit the United States. For others, tragedy, a criminal past, or injustice drove them away. Immigrants who wanted to enter, but failed to qualify because of laws or regulations, were cut off from their dreams. Even those who crossed America's threshold were subject to government control as aliens who, if they committed a crime, supported an unpopular political cause, or violated a regulation, could be subject to deportation.

Opposite: **Immigration interview on Angel Island, 1923**
National Archives, Records of the Public Health Service (90-G-124-479)

"convicted of a crime involving moral turpitude"

Below and following pages:
**Photographs and personal
descriptions and records
for immigrants about to
be deported from Ellis
Island, 1906–9**
*National Archives, Records
of the Immigration and
Naturalization Service*

The ultimate punishment for an immigrant was deportation. Individuals were deported for a variety of reasons. They might have had a physical or mental disability, held a belief in anarchy or polygamy, or been considered unable to support themselves financially, and thus "likely to become a public charge." Another reason for deportation was "moral turpitude." An individual who had served a sentence for a crime, or who was suspected of engaging in morally suspect activities, was considered unfit for admission, residency, or citizenship.

During the early 20th century, immigration officials photographed many of those who were about to be deported to create a record that would prevent their reentry and their use of aliases. These identity photographs included a written physical description that noted not only height, weight, age, and facial features, but also hat and shoe sizes.

Individuals were deported for serious crimes such as murder, robbery, or assault, but they were also deported for relatively minor offenses like stealing peas or causing a disturbance. Chinese immigrants and their allies thought it unfair that the Chinese were the only other group consistently photographed—believing this implied an association between the Chinese and criminality.

Personal description and record of DUBAS WASYL ex SS Kroonland, November 13, 1906.

Height:	5' 6 3/4"
Weight:	155
Hair:	Brown
Eyes:	Brown
Face:	Long, V shaped scar right cheek, large mole right of nose.
Forehead:	High
Nose:	Long, flat at bridge
Chin:	Round
Mouth:	Small, thick lips, chestnut moustache.
Ears:	Normal
Teeth:	Two missing lower right, remaining good.
Age:	33
Size of hat:	6 7/8
Size of shoes:	8

REMARKS: Native of Austria. Farm Laborer. Destined to friend Lucas Nebozenski, New York (no street address). Served nine months in prison; one month for stealing peas,and eight months for being an accomplice to thieves. Excluded as a person having been convicted of a crime involving moral turpitude.

DEPORTED: per SS Kroonland, November 21, 1906.

Personal description and record of WLADYSLAW PASTERNAK,
ex SS "Blucher", October 23, 1906.

 Height - 5' 6"
 Weight - 140
 Hair - Brown
 Eyes - Brown
 Face - Round; many eruptions on cheeks
 Forehead - High
 Nose - Flat
 Chin - Round
 Mouth - Small, thin lips, chestnut mustache, fan style
 Ears - Medium
 Teeth - Intact; small, clean, in good condition
 Age - 24
 Size of hat - 6 7/8
 Size of shoes - 8
 Native of Austria; laborer; was destined to aunt,
Antonia Mikratowa, 383 8th St., Jersey City, N. J. Served
two terms in prison, four months for assault and battery and
fourteen days for a similar offense. Excluded as a person
having been convicted of a crime involving moral turpitude.
 Deported SS "Blucher", November 1, 1906.

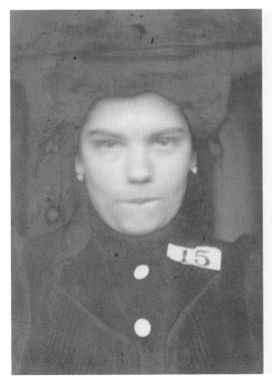

Personal description and record of LIZZIE VALIER, alias
ARZSI NAIT, alias ERZSEBETH FAITH, alias EZREBET JEYTD,
ex SS "Prinzess Irene", September 18, 1907.

 Height - 5' 1 1/4"
 Weight - 118
 Hair - Brown
 Eyes - Brown
 Face - Oval
 Forehead - Medium
 Nose - Small; broad at base
 Chin - Firm
 Mouth - Medium
 Ears - Medium
 Teeth - Good condition; none missing
 Age - 23
 Size of shoes - 4
 Prostitute. Deported SS "Barbarossa", January 4,
1909, under Department Warrant No. 51777/182 - D.

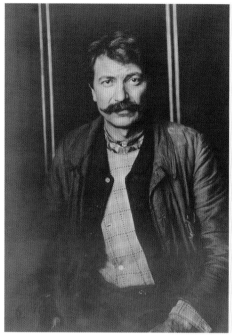

Personal description and record of FRANCESCO ZACCARO
ex SS Hamburg, February 17, 1907.

Height: 5' 7 1/2"
Weight: 155
Hair: Brown
Eyes: Brown
Face: Round
Forehead: High
Nose: Long
Chin: Round
Mouth: Small, thin lips, medium chestnut mustache.
Ears: Large
Teeth: Five missing – three upper left
 one " right
 " lower "

Age: 40
Size of hat: 7
Size of shoes: 9

 Remarks: Native of Italy – Was destined to mother-in-law
Maria Sanginito, 2173 1st Avenue, New York City. Served eight
days in prison for applying vile names to a woman.

 Excluded as a person having been convicted of a crime
involving moral turpitude.

 DEPORTED: SS "Hamburg" – February 20, 1907.

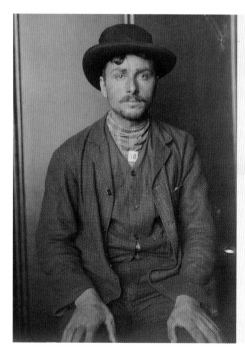

 Personal description and record of EL SAMOUR, MASSALEM
ex SS La Touraine – November 12, 1906.

 Height: 5 – 5 1/2
 Weight: 145
 Hair: Dark Brown
 Eyes: Dark Brown
 Face: Round, high cheek bones, dark moustache, scar on
 left cheek.
 Forehead: Medium
 Nose: Acquiline
 Chin: Medium and receding
 Mouth: Medium
 Ears: Medium
 Teeth: Intact
 Age: 22 years
 Size of hat: 7
 Size of shoes: 8 1/2

 REMARKS: Native of Syria. Farm laborer. Destined to brother
 Farah, 183 Third Ave.(or St.) Passaic, N. J. Served two
 years in prison for assaulting a man. Excluded as a person
 having been convicted of a crime involving moral turpitude.

 DEPORTED per SS "La Touraine – Nov. 15, 1906.

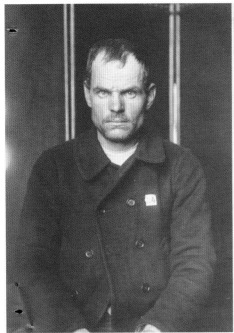

Personal description and record of DIMITROULIAS, DEMITRIOS
SS "St. Laurent" - November 15, 1906.

Height: 5 ft. 8 1/2 in.
Weight: About 160 pounds
Hair: Brown
Eyes: Brown
Face: Smooth - round - deep scar under left jaw
Forehead: Medium height
Nose: Medium size - broad at nostrils
Chin: Round - scar on left side
Mouth: Large - thick lips
Ears: Medium size - protruding
Teeth: Intact
Age: 28
Size of Hat: 7
Size of shoes: 8

 REMARKS: Native of Greece. Farm laborer. Destined to
cousin, Bill Anastasopoulas, 126 - 4th Ave. Pittsburgh, Pa.
Admitted complicity in the murder of Costas Alevizos, which
occurred in Greece in August, 1904. Excluded as likely to
become a public charge.

 DEPORTED: Via SS "Italia" - Dec. 6, 1906
 Ticket purchased by Greek Consul.

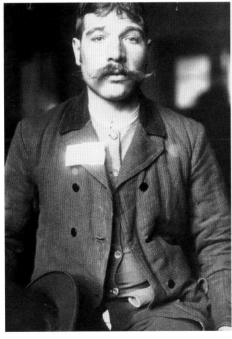

 Personal description and record of BALINE POLEDOVICS,
ex SS "Chemnitz", December 1, 1906.

 Height - 5' 10 1/2"
 Weight - 170
 Hair - Brown
 Eyes - Blue
 Face - Oblong; square and large jaws; small mustache
 Forehead - High and wrinkled
 Nose - Large; straight; broad below the eyes
 Chin - Square and large
 Mouth - Large; thick lips
 Ears - Large and protruding
 Teeth - Intact
 Age - 36
 Size of hat - 7 1/8
 Size of shoes - 9

 Native of Hungary; farm laborer; was destined to
half-brother, Ferencz Missik, 1016 Machen Avenue, Charleroi,
Pa. Served two terms in prison, three days for stealing wood
bottoms, and four days for a similar offense. Excluded as a
person having been convicted of misdemeanor involving moral
turpitude.

 Deported SS "Trawe", December 6, 1906.

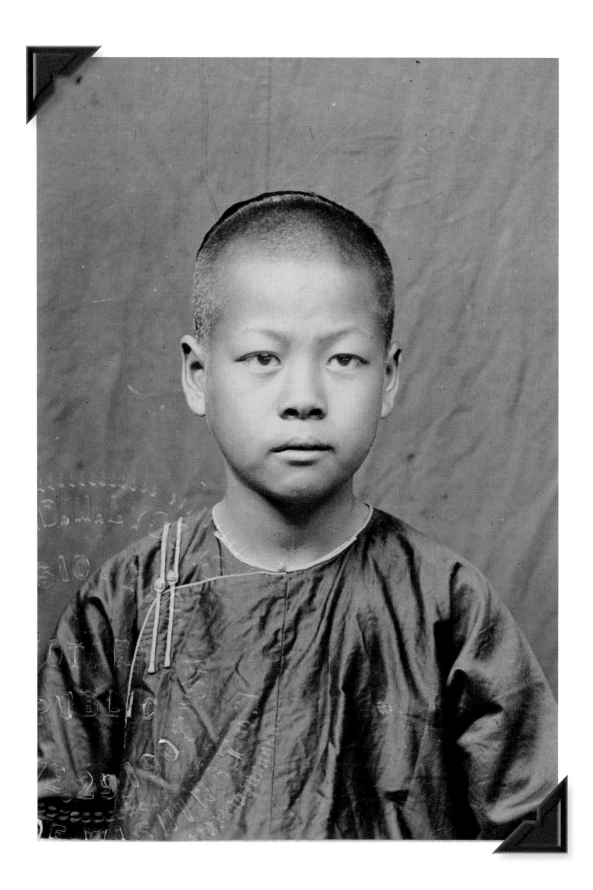

Rock Fee

"This is another of the many attempts . . . to make an American citizen out of a Chinese coolie."

Immigration inspectors were skeptical when Rock Hang, a Chinese cook who lived in Seattle, Washington, filed paperwork to allow his son, Rock Fee, to enter the United States. Rock Hang claimed his son was a U.S. citizen who had gone to China with his family in 1894 and was entitled to return to the land of his birth. Immigration officials doubted Rock Fee and suspected he might be a "paper son" who was posing as Rock Hang's son and using false documents to enter the country. Interviews with family members contradicted each other. There was no ship passenger record of Rock Hang returning to the United States from China after leaving his family there. And the individuals who gave evidence on his behalf were suspected of being "professional white witnesses" who had been paid for their testimony.

Rock Fee was denied entry, and when he appealed, the special immigrant inspector in his case concluded that "this is another of the many attempts . . . to make an American citizen out of a Chinese coolie."

Rock Fee was placed aboard the SS *Tremont* and deported to China on January 11, 1907.

Below right: "Application for Readmission of Native Born Son of Chinese Parents," for Rock Fee, August 9, 1906
National Archives, Records of the Immigration and Naturalization Service

Below left: "Memorandum for the Assistant Secretary," from Special Immigrant Inspector Fred Watts, Jr., January 9, 1906
National Archives, Records of the Immigration and Naturalization Service

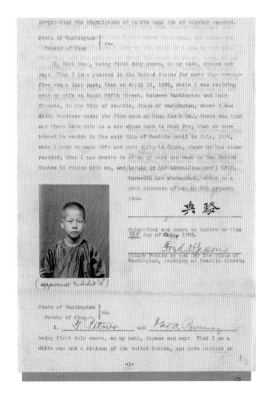

Olga Averbuch

"This girl is now in Russia, and has been making anarchistic speeches there."

On March 2, 1908, 18-year-old Lazarus Averbuch, a Ukrainian Jewish immigrant, rang the bell at the home of Chicago's chief of police, George Shippy. Three minutes later, Averbuch lay dying in Shippy's entryway with seven gunshot wounds. The police chief claimed that Averbuch had cut him with a knife and then shot his son and bodyguard. The local press accused Averbuch of being a foreign-born anarchist assassin. Chicago's Jewish community at first agreed with the police chief, but eventually suspected a cover-up and protested Shippy's actions. An inquiry eventually cleared the chief.

Whatever the truth about Averbuch's actions, the life of his sister, Olga Averbuch, was also forever changed by the events of March 2. Detained and questioned about her brother for three days without having been told of his death, the police then surprised her with his body. For the next few months she was caught up in sensationalistic press accounts, accused of anarchism, and at first prevented from properly burying her brother. Eventually, she decided to return to the Ukraine.

In October 1908, Chicago's chief immigration inspector wrote to the Commissioner-General of Immigration, enclosing two photographs of Olga, who, he claimed, was in Russia "making anarchistic speeches" and planning to return to the United States. He recommended copying and distributing the photographs so she could be identified if she tried to return.

Olga Averbuch never attempted to reenter the United States. She lived in the Ukraine until the 1941 German invasion, and she probably died in the Holocaust.

Department of Commerce and Labor
IMMIGRATION SERVICE

No. 507/25

OFFICE OF
IMMIGRANT INSPECTOR IN CHARGE
CHICAGO, ILL.

October 29,1908

Commissioner-General of Immigration,
 Department of Commerce and Labor,
 Washington, D.C.

Sir:

 I forward herewith two photographs of one Olga Averbuch, who is a sister of Harry Averbuch, the anarchist who was killed in the house of Chief of Police Shippy, of this city, some time ago. This girl is now in Russia, and has been making anarchistic speeches there. The police authorities advise me that she contemplates returning to this country in a short time. She is an alien. Her description is as follows: 5' 5" high, 105 lbs.; dark chestnut hair; delicate; wears glasses; speaks German, Russian and a little English.

 I would suggest that the Bureau have these photographs copied, returning the originals to this office, they having been loaned by the Police Department.

 Respectfully,
 Daniel D. Davies
 Immigrant Inspector in Charge

Enc.1391

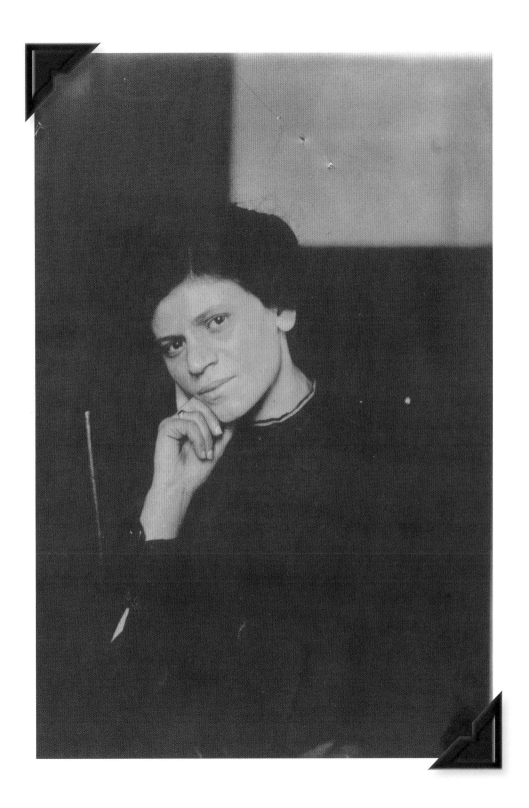

Chun Wing Kwong
"This note is an indication of fraud."

Chun Wing Kwong arrived in Honolulu, Hawaii, aboard the SS *Mongolia* on December 22, 1914. He claimed to be the son of Chun Seak, a Chinese merchant who ran a small store near Honolulu. As a merchant, the elder Chun could legally bring his child into the United States, but immigration inspectors in Honolulu found several troubling discrepancies during their interviews. Both Chuns had described their home village differently, and they had differed about when Chun Wing Kwong was born, where he went to school, and when they had last seen each other. Finally, they believed Chun Wing Kwong was at least 21—too old to qualify as a minor child.

But the most damning evidence against Chun Wing Kwong was a package of cigarettes sent to him in detention. Officials noticed that the seal of the package was loose. When they opened it, they discovered a note in Chinese: "Grandmother bound feet. Chun Seak with me not recognize. Sure remember." Such "coaching notes" were often smuggled to Chinese detainees so their interview answers would match those of their friends and family.

The immigration inspectors believed "this note is an indication of fraud," and they denied Wing Kwong entry. His appeals were turned down, and he was deported on February 12, 1915.

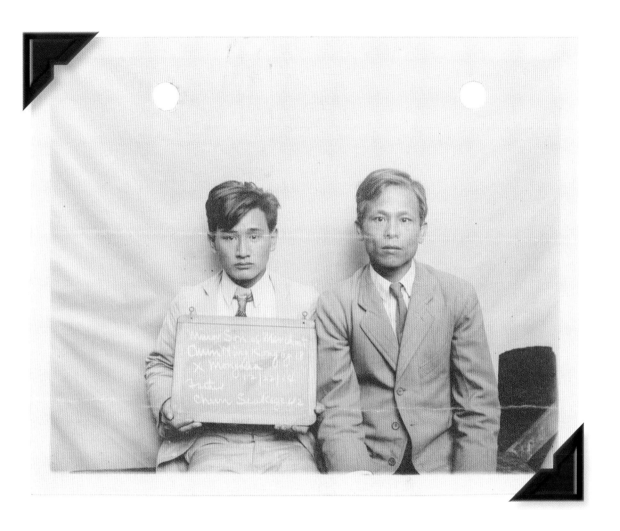

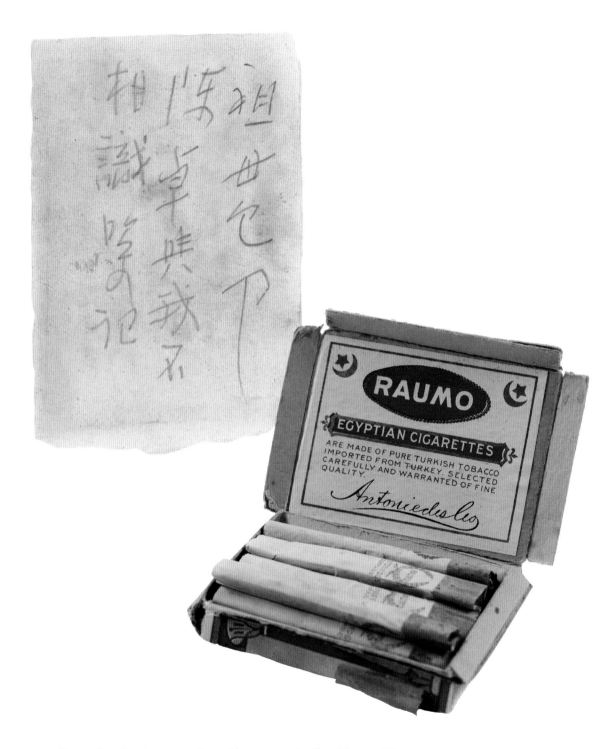

Raumo Egyptian cigarettes package with accompanying "coaching note" in
Chinese, ca. 1914–15. The note reads, "Grandmother bound feet. Chun Seak
with me not recognize. Sure remember."
National Archives, Records of the Immigration and Naturalization Service

Form 429

NOTICE TO REJECTED CHINESE APPLICANT, UNDER RULE 5

Department of Commerce and Labor

IMMIGRATION SERVICE

To *Chun Wing Kwong* PORT OF *Honolulu T. H.*

January 12, 191 5.

You are hereby notified that your application for admission to the United States is denied. From this decision you have the right of appeal to the Secretary of Commerce and Labor. If you desire to appeal, you must notify the officer in charge at this port within two days of the receipt of this notice.

陳東榮江 ——— 12 o'clock M

TRANSLATION.

之	內	限	接	此	臣	上	能	不	之	所	特
總	報	期	此	案	倘	工	將	準	稟	求	字
理	知	兩	字	務	爾	商	此	但	現	入	通
方	本	日	之	須	欲	部	案	爾	已	美	知
可	港	之	後	得	提	大	移	可	批	國	爾

11—1933

Richard L Halsey

Inspector in Charge.

24

"Notice to Rejected Chinese Applicant, Under Rule 5," January 12, 1915

National Archives at San Francisco, Records of the Immigration and Naturalization Service

Form 432

APPLICATION OF LAWFULLY DOMICILED CHINESE LABORER FOR
RETURN CERTIFICATE

[ORIGINAL]

U. S. DEPARTMENT OF LABOR
IMMIGRATION SERVICE

#20161

Office of Inspector in Charge

Port of Minneapolis, Minn.

September 5, 1922 , 191

To Chas W. Seaman

Chinese and Immigrant Inspector

Minneapolis, Minn.

Sir: It being my intention to leave the United States on a temporary visit abroad, and to depart and return through the Chinese

port of entry of Seattle, Wash , I hereby apply, under the provisions of the laws of the United States
relating to the exclusion of Chinese (specifically Section 7 of the Act approved September 13, 1888), and of Rules 12 to 14 of the
Regulations of the Department of Labor drawn in conformity therewith for pre-
investigation of my claimed status as a lawfully domiciled laborer. I submit here-
with my certificate of residence, No. * * * * * * * (or a
certified transcript of a court record of my discharge as a person lawfully entitled
to be in the United States). I am prepared to appear before you personally at
such time and place as you may designate, and to produce at such time and place
witnesses to prove my statutory qualifications for a return certificate, as follows:

FAMILY: * * *

Wife, named

Residing * * *

Child or children, named

Residing

Parent, named * * *

Residing

OR

PROPERTY or DEBTS, or both (aggregating at least $1,000 in value) described as follows:

See my husband's application.

13-10

I HEREBY AGREE that the above-described claims shall remain as they now exist until my return.

Signature in Chinese Mrs. Yee Shing (Mary Yee)

Subscribed and sworn to before me, this

Signature in English Mrs Yee Shing

6th day of September

Address 518 No. Minnesota Ave. Sioux Falls, S.D.

1922.

Height five (5) feet Two (2) inches

Physical marks or peculiarities scar below right eye

Lettie O. Lein

Chinese and Immigrant Inspector

Notary Public
Minnehaha Co., S.D.

Minneapolis, Minn.

September 8, 1922 191

Respectfully forwarded to
COMMISSIONER OF IMMIGRATION or INSPECTOR IN CHARGE, Port of Seattle, Wash.
accompanied by triplicate hereof, and report, and transcripts of testimony in accordance with Rule 13.

Chas W Seaman

Chinese and Immigrant Inspector.

Port of Seattle Wash

Sept 18 , 191

This is to certify that the Chinese laborer named herein, and whose photograph is attached, under the signature of the investi-
gating officer and under my signature and seal, to the above application, has filed in my office the duplicate of this application, and
evidence in corroboration, of his claimed status. Upon his return to this port and his identification as the person to whom this
paper, thus approved, is delivered, he will be permitted to reenter the United States, unless pending such return it has been found
that his claim is false.

14—76

Commissioner of Immigration or Inspector in Charge.

Mary Yee
"Application of Lawfully Domiciled Chinese Laborer . . ."

In 1922, Yee Shing, a Chinese merchant living in Sioux Falls, South Dakota, wanted to take his family to China to educate his American-born children. Several months before their departure, Yee filed the paperwork for a "return certificate," establishing his right to come back to America and ensuring that his children could also return. Yee's wife, Mary Kasky Yee, was a white woman who claimed she had been born in Michigan. The immigration inspector assigned to the case believed that since Mary was a U.S. citizen she did not need to file any further paperwork.

The inspector was wrong. Under the Immigration Act of 1907, a female U.S. citizen who married a citizen of another nation automatically lost her U.S. citizenship and took on the nationality of her husband. In other words, when Mary married Yee Shing, she became Chinese. As "a lawfully domiciled Chinese Laborer," Mary filled out her paperwork, attached her photograph, and submitted to an interview. Her return certificate was approved, and the family left Seattle for China on September 16, 1922.

Opposite: "**Application of Lawfully Domiciled Chinese Laborer for Return Certificate,**" **for Mary Yee, September 5, 1922**
National Archives at Seattle, Records of the Immigration and Naturalization Service

Below: **Mary Yee and Yee Shing with their children, 1922**
National Archives at Seattle, Records of the Immigration and Naturalization Service

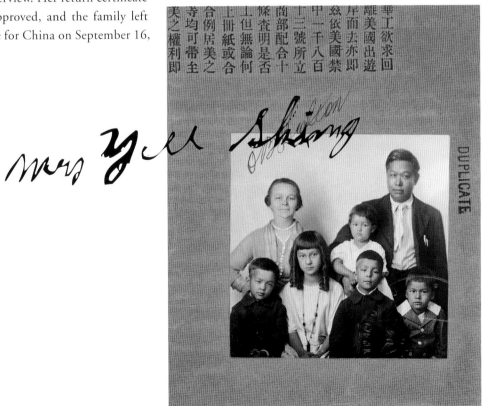

Lee Puey You
"sitting at Angel Island, I must have cried a bowlful of tears"

Twenty-three-year-old Lee Puey You arrived in San Francisco on April 13, 1939, claiming to be the daughter of a U.S. citizen. Traveling under the name Ngim Ah Oy, Lee had left her poverty-stricken family in war-ravaged China to marry Woo Tong, a widower 30 years her senior.

Immigration officials interviewed her for three days about her family's history, her village, her home, and her neighbors. When her answers differed from those of her "father," officials ordered her deported. While Lee's "family" appealed her case all the way to the U.S. Supreme Court, she spent 20 months on Angel Island. Years later, she recalled, "sitting at Angel Island, I must have cried a bowlful of tears."

Lee was deported in 1940, but in 1947, after the repeal of the Chinese Exclusion Acts, she returned to the United States posing as a "war bride" to marry Woo Tong. When she finally met him, she discovered his wife was still alive. She was forced to live with the couple and work for them until Woo died in 1950.

After Woo's death, Lee Puey You met and married Fred Gin, and together they raised four children. In 1955, she was investigated for entering the country using false documents. Lee confessed to this, and was ordered deported, but this time her appeals were successful. She was allowed to stay, and she became a U.S. citizen in 1959.

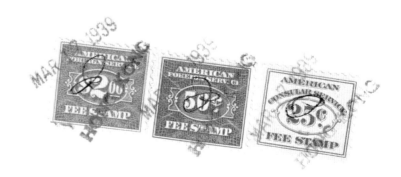

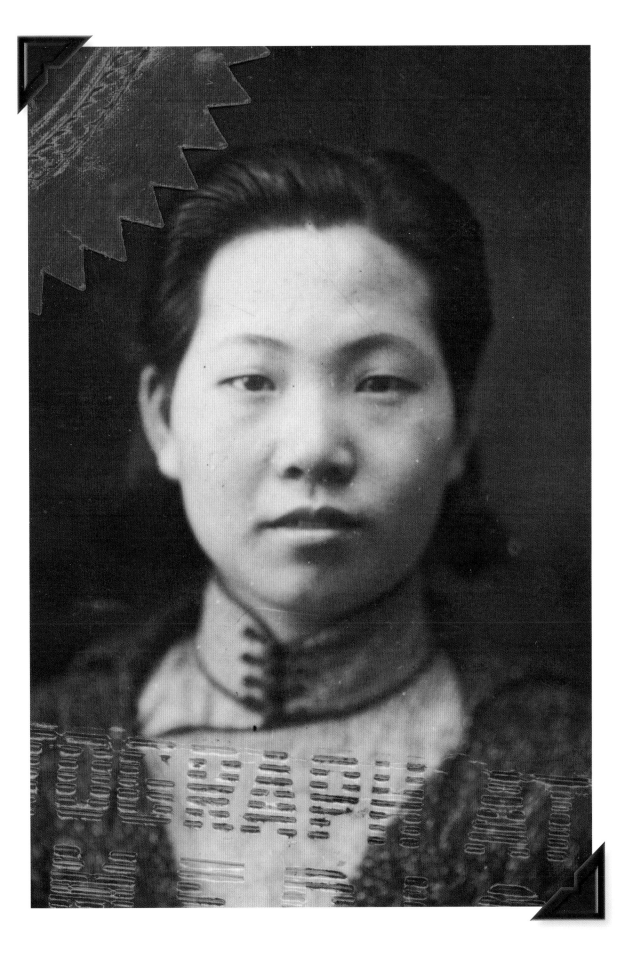

COLONY OF HONG KONG :
CITY OF VICTORIA : ss.
CONSULATE GENERAL OF THE :
UNITED STATES OF AMERICA :

 Before me, John C. Pool, Vice Consul of the United
States of America in and for the consular district of
Hong Kong, duly commissioned and qualified, personally
appeared the individual whose photograph is attached
hereto and who, being duly sworn according to law,
deposes and says:

 My full and correct name is NGIM Ah-oy;

 I was born on CR4-11-27 (January 2, 1916) at How
Chung Village, Nam Long, Chungshan District, Kwangtung
Province, China;

 My father is NGIM Lin, an American citizen;

 I am the subject of the affidavit executed by
my father, NGIM Lin, attached hereto;

 I have never been married;

 AND further deponent saith not.

—————————————————————————
 (NGIM Ah-oy).

 Subscribed and sworn to before me this 17th day
of March, 1939.

 John C. Pool
 Vice Consul of the United
 States of America.

Service No. 14347-5

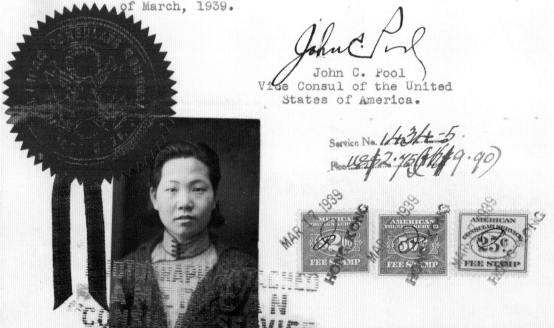

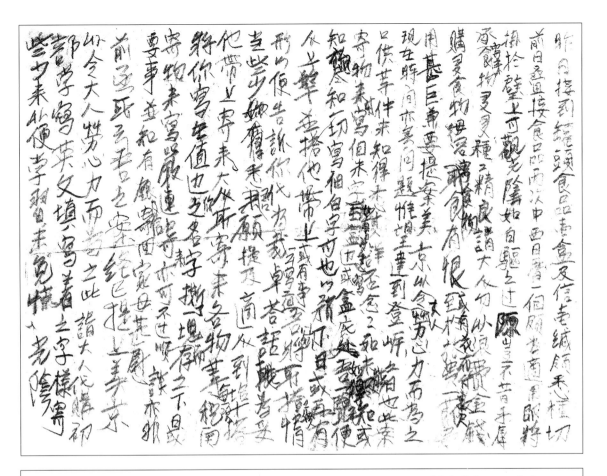

Yesterday I received a box of canned food and a letter which I have noted. Some days ago I had received some foodstuff twice and a Chinese-American calendar which is very useful and which I have hung on the wall.

The foodstuff you sent me is very good, but I would ask you not to spend so much to buy food to send me, because I cannot eat so much. Send me some calico, if you have it.

The hotel expenses must be very great, and then you have to appeal the case to Washington. That means money and anxiety on your part. I do not mind to prolong my stay here in order to get landed. I do not know whether you have understood the testimony in this case or not. If you do not know it all, you can write the word "mei" on the edge or in the bottom of a box of food you might send me, and when I see it I will understand. Write that word plainly, so that I will send it to you by some one who will be landed later. I want to tell you the answers I gave to the questions, so that you may know them and advise me concerning my answers. If you have understood it, I do not wish to talk about it now. When some one goes to the city, I will send it to you by him (or her).

Every time you sent me something, the officer tore away the name on the side and kept it until the next day. When you send me things, you can write "sent by Ngim Lin", but that's not important. I am glad to know you have sent mother a letter and some money. Your last letter said that the case had been appealed to Washington, and that costs you money and gives you anxiety. Please get me a beginner's book to learn how to write English, so that I may make use of my time here.

To my father Ngim Lin, C/O maternal uncle Woo Tong.

(NOTE: The Chinese paper from which the above translation is made is a draft of a letter, rather poorly written, but the translation is substantially and almost literally correct. Interp. H. K. Tang, 5-19-39).

AMERICAN CONSULATE-GENERAL

Shanghai, China

SECTION 6 STUDENT PRECIS.

Name: OKYUN KIM

Non-quota Immigration Visa No.: *16/1926*

Section 6 Certificate issued by the Commissioner for Foreign Affairs

at Shanghai on February 11, 1926

Visa granted by this Consulate-General on: February 17, 1926

Bearer's birthplace: Korea

Family (ages by reckoning): Not married.

Review of bearer's education: Attended Middle School from 1914-1923 the Yei Sin Baptist Missionary School, Masan, Korea, graduating in 1923. 1923-1925 attended Wei Ling Girls' Academy, Baptist Mission, Soochow, China.

Plans for education in the United States: Will attend San Francisco National Training School, San Francisco, California, to study the Bible and for higher education and intends to return to China to do missionary work.

Provision for financial support: Will be supported by her brother, Mr. Kung Cho Kim of Masan, Korea, a merchant, who will give her 1500 Yen per year. He is worth approximately 20,000 Yen.

Reference in the United States: Mrs. Henry Shim, Sister, 631 Jackson Street, San Francisco, California.

Consular investigation and remarks: Examination has been made of the applicant who presented a letter from her brother, Mr. K. C. Kim, guaranteeing full support. Letters are also on file from Mr. K. B. Oak of the A.C.K. Company, certifying to the ability of the applicant's brother to support her, also from Mr. George A. Fitch, Secretary of the Young Men's Christian Association, Shanghai and Sophie S. Lanneau, Principal of the Wei Ling Girls'Academy, Soochow, vouching for the applicant's educational purpose and the financial ability of the applicant's brother. Letter on file in this office dated July 9, 1925 from the San Francisco National Training School admitting applicant thereto.

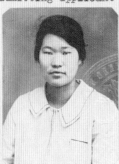

Intended departure.

Steamship: PRESIDENT PIERCE
Sailing date: February 18, 1926
Port of entry: SAN FRANCISCO, California

Edwin S. Cunningham
American Consul-General.
WBW

Kim Ok Yun
"intends to return to China to do missionary work"

When Kim Ok Yun applied for and was granted a visa in February 1926, she told the American consul in Shanghai, China, she was a naturalized Chinese citizen and was planning to study in San Francisco and then return to China "to do missionary work."

The truth was more complicated. Ok Yun was a Korean nationalist—a member of the outlawed Mansei movement that opposed the Japanese occupation of her homeland and policies such as banning the Korean language in schools, closing newspapers, and prohibiting free assembly.

As a Korean, Ok Yun could not get a passport from the Japanese, so she disguised herself as an elderly Chinese woman and fled across the Korean border into China. After studying English for several years, she obtained a Chinese passport and sailed to San Francisco claiming to be a student—one of the categories of Asians allowed to come to the United States. In San Francisco, she lived with her sister, attended a teachers college, and avoided political involvement. In 1933, after her graduation, Ok Yun returned to Korea, taught school, and once again became active in the nationalist cause. Her relatives in America believed she might have been killed by the Japanese secret police.

Opposite: "American Consulate-General Shanghai, China, Section 6 Student Precis" for Kim Ok Yun, February 11, 1926
National Archives at San Francisco, Records of the Immigration and Naturalization Service

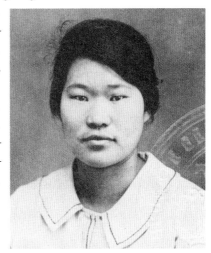

Carmen Wienke

"a native of the Philippine Islands, and not a citizen of the United States"

Opposite: **Consent for Custody for Carmen Wienke, June 12, 1936**
National Archives at San Francisco, Records of the Immigration and Naturalization Service

Philippine-born Carmen Wienke married a former U.S. serviceman in 1919. By the early years of the Great Depression, she and her six children were living in San Francisco, California, where they, like so many others, were facing tough economic times. After 1934, Carmen also faced changes to her immigration status. The Tydings-McDuffie Act had granted Philippine independence, but changed her status from "U.S. national" to "alien." Congress had created a repatriation program under which Filipinos living in northern California were given a one-way ticket should they voluntarily return to the Philippines. According to Wienke, a social worker came to her home and threatened to cut off her family from unemployment relief unless she returned to the Philippines. She and her family sailed for Manila in 1936.

By 1939, Wienke had second thoughts. She was convinced that her marriage gave her and her children U.S. citizenship, but when she attempted to reenter the United States and rejoin her husband, she and her children were detained on Angel Island. Officials ruled against her on two legal technicalities, and after a number of appeals, she and her children were deported back to Manila in March 1940. They had been detained for eight months.

In December 1941, the Japanese invaded and eventually occupied the Philippine Islands. Carmen and her family spent the war years held by the Japanese in an internment camp. When they were released in 1945, Carmen and her family sailed to the United States, described as a citizen who had been born in San Francisco. She became a naturalized United States citizen in 1960.

[Note: Strike any or all terms included in parentheses not applicable in this case]

CONSENT FOR CUSTODY

I, _Carmen Wienke_, (the father, mother, or legal custodian of) the Filipino named in the authority on the reverse side hereof, and whose photograph is attached hereto, as an evidence of my good faith and intentions in filing this application for return to Manila, Philippine Islands, and in consideration of the approval thereof by the Secretary of Labor, do hereby voluntarily and of my own free will place (myself, him, or her) in the custody of the officer or person designated to supervise (my, his, or her) return to Manila, Philippine Islands until (my, his, or her) arrival at that destination.

MRS. C.H. WIENKE
12042
368 P 1963

Mrs Carmen A Wienke
Signature of applicant.

Above signature witnessed by: _Rose M Huebel_

14—3276

Immigration processing on Ellis Island, ca. 1920

National Archives, Records of the Public Health Service (90-G-125-20)

Staying

Coming to America meant leaving behind the familiar. And while not all immigrants chose to stay, for those who did, making a life in a new land presented both opportunities and challenges. Feelings of loss and nostalgia over what was left behind mixed with the thrill of greater freedom and the chance to begin again. The safety and comfort of associating with compatriots from "the old country" competed with a desire to demonstrate loyalty to new communities and a new nation. American ideals of inclusion, democracy, and individual rights faced off against the reality of prejudice, discrimination, and stereotyping.

For many, those struggles were resolved, in part, by taking the steps to become U.S. citizens. For others, it was enough to live as aliens in America for the rest of their lives.

Opposite: **"Street Corner Next to Federal Building Where U.S. Dept. of Labor Handles Naturalization of Immigrants," New York, New York, 1939 (detail)** *National Archives, Records of the National Youth Administration* (119-G-M-29)

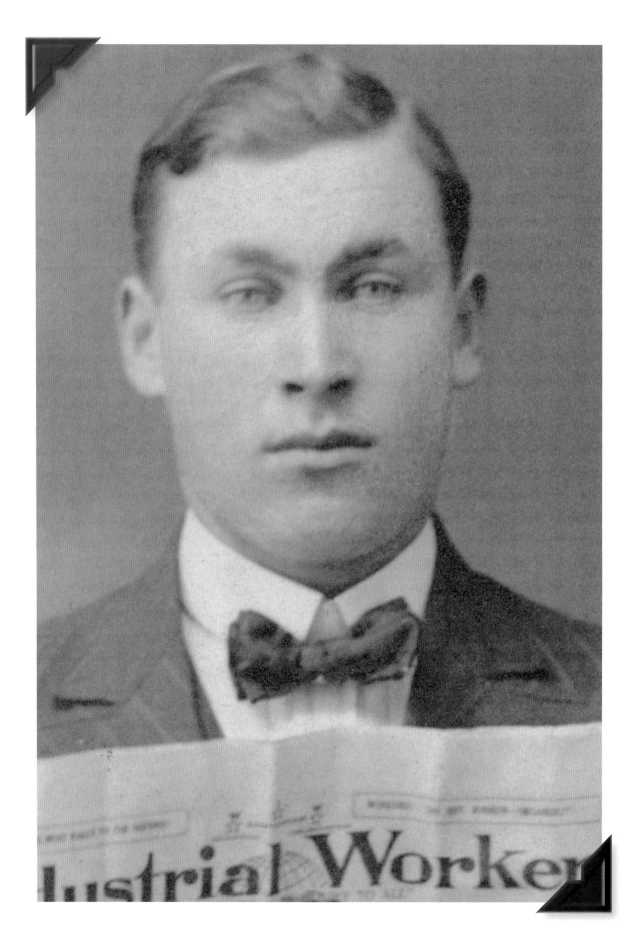

Louis Vagadori
"he is a destructionist"

On June 12, 1918, the San Francisco Police Department conducted a raid on the headquarters of the "Latin Branch" of the Industrial Workers of the World (IWW), a radical labor union. Nine men were arrested, including 21-year-old Italian factory worker Louis Vagadori. All were charged with "advocating and teaching the unlawful destruction of property," a violation of the Immigration Act of 1917, and turned over to the Immigration Service for deportation. The IWW's aggressive anticapitalism and its support of striking workers drew hostility from law enforcement officials. Once America entered World War I, the IWW's activities were deemed not only dangerously radical, but sympathetic to the enemy. Alien radicals were often targeted for surveillance, arrest, and deportation.

According to a report written by the police captain who led the raid, Vagadori was "a destructionist" because of his association with one of the other men arrested, who was under indictment for attempting to blow up the California governor's mansion and who had been caught with incriminating radical literature. To the policeman, Vagadori "necessarily must have held the same views." Besides, he had also been in possession of radical postcards and a photograph showing him posing with a radical newspaper.

At his immigration hearing, Vagadori claimed he had only briefly been a member of the IWW, and that he would quit if his membership were illegal. He assured officials he did not believe in the unlawful destruction of property or in political assassination. Officials believed him and ruled that he would not be deported. Vagadori became a citizen in 1929 and died in 1968.

Opposite: Louis Vagadori

Below: Postcard, "Proletari di Tutti i Paesi Unitevi!" ("Workers of the World Unite!"), seized from Louis Vagadori, ca. 1918
National Archives, Records of the Immigration and Naturalization Service

Form 565

APPLICATION FOR WARRANT OF ARREST UNDER SECTIONS 20 AND 21 OF THE ACT OF FEBRUARY 20, 1907

U. S. DEPARTMENT OF LABOR
IMMIGRATION SERVICE

(Place) San Francisco, Calif.

June 24, 1918 , 191

The undersigned respectfully recommends that the Secretary of Labor issue his warrant for the arrest of Louis Vagadori

the alien named in the attached certificate, upon the following facts which the undersigned has carefully investigated, and which, to the best of his knowledge and belief, are true:

(1) (Here state fully facts which show alien to be unlawfully in the United States. Give sources of information, and, where possible, secure from informants and forward with this application duly verified affidavits setting forth the facts within the knowledge of the informants.)

This alien was one of a party of nine persons, all members of the I.W.W. arrested by the San Francisco Police Dept. at a meeting of the I.W.W. organization attended by Basile Saffores, who is under indictment charging him with being connected with the dynamiting of the Governor's residence at Sacramento, Calif., and in whose possession at the time of his arrest were found, a document showing him authorized to solicit subscriptions for the I.W.W. newspaper "Industrial Worker" published at Seattle, Washn., a certificate signed by the General Secretary of the I.W.W. organization authorizing him to collect dues and initiate new members, a document showing him to have been collecting funds for the defense of the imprisoned members of the I.W.W. and a Recruiting Union I.W.W. Secretary's financial report blank showing thereon as having for sale, among other things, books on Sabotage by Flynn, Smith and Pouget. Inasmuch as Basile Saffores is advocating the destruction of property through the literature reffered to, this alien necessarily must have held the same views, therefore warrant is applied for under Sec. 19 of the Immigration Law on the ground that he is a destructionist.
Enclosure: Report of Captain J. J. O'Meara of the San Francisco Police Dept. dated June 13, 1918.

(2) The present location and occupation of above-named alien are as follows:

City Prison, San Francisco, Calif. 7/6/18

Pursuant to Rule 22 of the Immigration Regulations there is attached hereto and made a part hereof the certificate prescribed in subdivision 2 of said Rule, as to the landing or entry of said alien, duly signed by the immigration officer in charge at the port through which said alien entered the United States.

Encl: 6424
JR

14—75

(Signature)

(Official title) Commissioner

Above: "Application for warrant of arrest . . ." with excerpts from the report of Capt. J. J. O'Meara, San Francisco Police Department, on the arrest of Louis Vagadori, recommending his deportation, June 24, 1918
National Archives, Records of the Immigration and Naturalization Service

Opposite: "Exhibit E" photograph of Louis Vagadori (top left) and others holding radical newspapers and an Industrial Workers of the World pennant, 1918 (detail)
National Archives, Records of the Immigration and Naturalization Service

Maria Zamora de Garcia

"Manner of arrival: On Foot"

Immigrants from Mexico and the rest of the Western Hemisphere were not subject to the annual numerical quotas imposed by the National Origins Act of 1924. But the act also required a visa—a package of documentation including a photograph—of all travelers. As a result, crossing the Mexican-U.S. border became more difficult and expensive.

Maria Zamora de Garcia was born in La Colorada, Mexico, in 1900. She first entered the United States in 1918 without registering and without paying the required $8 head tax, presumably because she came with her husband who was a Mexican government official and she and her family would have been classified as nonimmigrants. After the 1924 law made crossing the border more complicated, she wanted to document her status and that of her Mexican-born child. So, on July 22, 1924, she went to Nogales, Arizona, crossed into Mexico, and visited the U.S. consulate there to obtain a visa and pay the head tax. Maria walked back through the gate into the United States (arriving "On Foot") and was admitted as a lawful, permanent resident alien.

In 1940, Maria Garcia became a U.S. citizen. She did not have to file a declaration of intention or wait the usual five years as her second husband, Nicolas Blas Garcia, was a United States citizen who was born in Texas.

U.S. DEPARTMENT OF LABOR
IMMIGRATION AND NATURALIZATION SERVICE No. 23 81375

CERTIFICATE OF ARRIVAL

I HEREBY CERTIFY that the immigration records show that the alien named below arrived at the port, on the date, and in the manner shown, and was lawfully admitted to the United States of America for permanent residence.

Name: Maria Zamora de Garcia
Port of entry: Nogales, Arizona
Date: July 22, 1924
Manner of arrival: On Foot

I FURTHER CERTIFY that this certificate of arrival is issued under authority of, and in conformity with, the provisions of the Act of June 29, 1906, as amended, solely for the use of the alien herein named and only for naturalization purposes.

IN WITNESS WHEREOF, this Certificate of Arrival is issued

MAR 1 1940

James L. Houghteling

WH

JAMES L. HOUGHTELING,
Commissioner.

Form 160 U.S. GOVERNMENT PRINTING OFFICE 14—2572

María Z de Guux

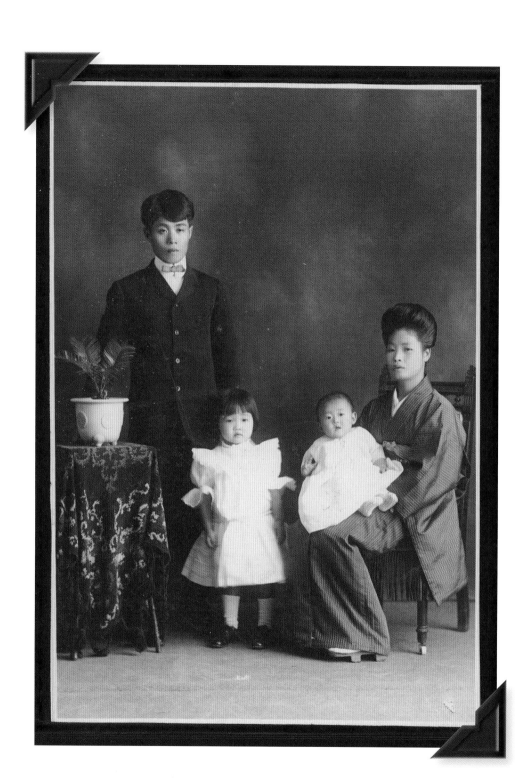

Kaoru Shiibashi
"I wanted to see my native land."

The 1907 "Gentlemen's Agreement" between the United States and Japan prevented Japanese laborers from emigrating to the United States. The 1924 National Origins Act effectively ended all Japanese immigration. Thus, American citizens of Japanese ancestry living in Japan, who could legally return to the United States, were in great demand to work on Japanese farms in California.

In 1931, Kaoru Shiibashi, a 23-year-old Hawaiian-born man who had been taken to Japan as a toddler, sailed to San Francisco "to see my native land" and to work on a farm near San José, California. When he arrived, immigration inspectors detained him on Angel Island and launched an investigation into his U.S. citizenship. Kaoru provided them with a family photograph of himself as an infant that was taken in Hawaii and a copy of his Hawaiian birth certificate. However, the inspectors became suspicious when interviews with him and his family differed and no one in Hawaii could identify him in the photograph.

Kaoru was initially denied entry, but he was eventually admitted on appeal, and worked as a farm laborer for the next 10 years. During World War II, he was among 120,000 Japanese Americans detained under Executive Order 9066. After his release from the Heart Mountain internment camp in Wyoming, he returned to farm in California.

Opposite: **Kaoru Shiibashi as an infant with his parents, ca. 1908**
National Archives at San Francisco, Records of the Immigration and Naturalization Service

Below: **Hawaiian birth certificate for Kaoru Shiibashi, June 23, 1908**
National Archives at San Francisco, Records of the Immigration and Naturalization Service

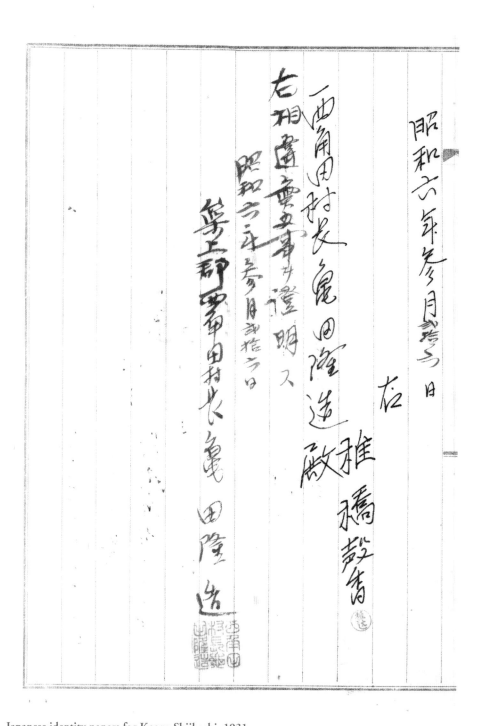

Japanese identity papers for Kaoru Shiibashi, 1931
National Archives at San Francisco, Records of the Immigration and Naturalization Service

證明書

福岡縣築上郡西角田村大字石塚参九六番地ニ

雄ニ橋馨香

昭和四拾壹季六月九日生

此段奉願ニ候也。

人ニ相違ナキ事ニ御證明被下度、

父要ナ上候間、茲ニ貼付ノ寫真ハ、

生、處今般更ニ薬會篤國ヘ渡航ニ

右ハ来領事館在ナルノ府ニ於テ出

Stephan Sevastian Bondareff
"crossed the Rio Grande . . ."

Following page, left:
"Application for Registry of an Alien Under an Act of Congress, Approved March 2, 1929, as Amended on June 8, 1934," August 11, 1934
National Archives, Records of the Immigration and Naturalization Service

Following page, right:
"Supplement to Application for Registry of an Alien," August 1934
National Archives, Records of the Immigration and Naturalization Service

A refugee from the 1917–21 Russian Civil War, Stephan Bondareff served in the White Russian Army that was defeated by the Red Army (Bolsheviks), who created the Soviet Union. After fleeing Russia in 1920, he traveled to Turkey, Bulgaria, and finally to Paris, France, where he was hired by the Miller Brothers 101 Ranch Wild West Show as a "cossack horse trick rider." After briefly working in the United States, he traveled with the show to Laredo, Mexico, in December 1926. On September 12, 1927, fearing he would not be allowed to enter the United States since he had no visa, Stephan "crossed the Rio Grande River at Eagle Pass Texas." He settled in Dearborn, Michigan, and worked for the Ford Motor Company.

Seven years later, Stephan took advantage of a law designed to allow Russians who had fled the Soviet Union without proper documentation to create a record of their arrival and apply for permanent residence. He filed to legalize his status in August 1934, writing that he was a refugee without a passport, and that if he returned to the Soviet Union, "they would put me in the jail first and then kill me."

Immigration officials created a record describing Bondareff's river crossing, and he was granted permanent resident status. He became a U.S. citizen in 1937, and died in 1978.

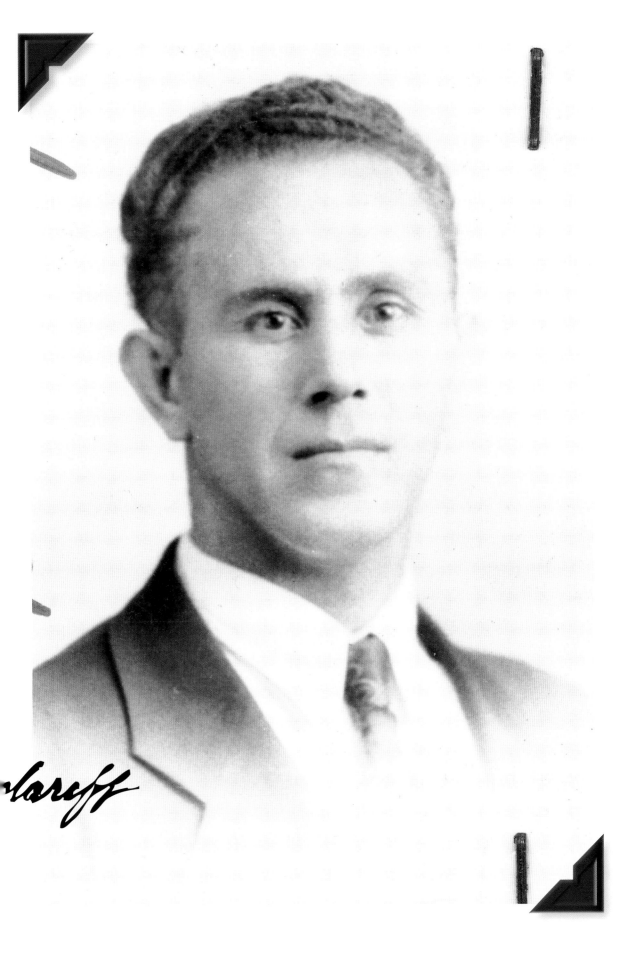

Form 659

APPLICATION FOR REGISTRY OF AN ALIEN UNDER AN ACT OF CONGRESS
APPROVED MARCH 2, 1929

Detroit,Michigan
6050/A-21

AS AMENDED ON JUNE 8, 1934

REFUGE

U. S. DEPARTMENT OF LABOR
IMMIGRATION SERVICE

(This application should be carefully studied before preparation and when prepared should be filed either in person or by mail at the immigration office located nearest alien's place of residence.)

IMMIGRATION AND NATURALIZATION SERVICE

August 11 19 3 4

RECEIVED
AUG 17 1934
Registry Division
Detroit, Mich.

To Commissioner General of Immigration,
Washington, D. C.

Through Immigration Officer at *Detroit Michigan*

SIR: I, the undersigned, an alien, believing that there is no record showing that I am now a lawful permanent resident of the United States, hereby request that, under the provisions of an act of Congress, approved March 2, 1929, a record of registry of my arrival in the United States be made. I hereby agree to appear in person at such time and place as may be designated for examination regarding the claims made by me, and to produce evidence in support thereof. This application is submitted in duplicate with my photograph affixed to each, together with four additional copies of the same photograph, which photographs are 1¾ inches in width by 2¼ inches in length, taken from the same negative, not retouched or mounted, on white background, representing me without hat, showing full front view, and signed (not printed) by me in such a manner as not to obscure my features. I inclose herewith postal money order in the sum of $20, payable to the Commissioner General of Immigration, Washington, D. C. In support of my application I make the following statements:

THE DATA IMMEDIATELY FOLLOWING ARE GIVEN AS OF THE DATE OF THE ENTRY UPON WHICH I BASE THIS APPLICATION

Name given at birth *Stephan Sevastian Bondareff*
(First) (Middle) (Last)

I entered under the name of ″ ″ ″
(First) (Middle) (Last)

My age was *25-8* My occupation was *Served in the Russian White army*
(Yrs.) (Mos.)

I arrived at the port of *New York City N. Y.* on (date) *March 27 1926.*
(Seaport or land border port) (Month) (Day) (Year)

I {was / was not} inspected and admitted by an immigrant inspector. I came on the vessel *Berengaria*
(Name of vessel)

(If means of conveyance to the United States was other than by vessel, describe such conveyance)

Brought by Miller Bros 101 Ranch from Paris on Dec 31,1926 was brought to Laredo Mexico by Mr. Miller

(If entry occurred at other than regular seaport or land border port, describe circumstances of entry including date) as accurately as possible, naming the State in which, and city or town at or near which, entry was effected)

On Sept 12,1927 crossed the Rio Grande at Eagle Pass Texas.

AUG 21 1934
REGISTRY AND VERIFIED

(1)

14—2606

Form 659-A

SUPPLEMENT TO APPLICATION FOR REGISTRY OF AN ALIEN

——— ——— REFUGEE

U.S. DEPARTMENT OF LABOR
IMMIGRATION AND NATURALIZATION SERVICE

——— ———

(The data called for below should be furnished by aliens who are applying
for registry under the Act of June 8, 1934, amending the Act of March 2, 1929,
and this form shall be executed and considered as a part of the application Form
659, in such cases.)

Since leaving the country of my nativity, I have resided in each of the
following countries, respectively, for the periods of time as indicated below:

Country	Province or State	City or Town	From Month	Year	To Month	Year
Bulgaria	Sofia	Sofia	May	1921	June	1935
France	Paris	Paris	June	1935	Sept	1935
England	London	London	Sept	1935	Dec	1935
France	Paris	Paris	Dec	1935	Mar	1936

I believe that I was in the United States prior to July 1, 1933, as a bona
fide political or religious refugee for the following reasons: _No diplomatic
relations between United States and U.S.S.R. I fought
with the Russian White Army. after revolution fled as a
political refugee to Sofia Bulgaria_

I believe that I could not be deported from the United States prior to July
1, 1933, for the following reasons: _No diplomatic relation between
United States and U.S.S.R._

I hereby acknowledge that I have executed the foregoing as a part of my ap-
plication for registry on Form 659.

Stephen Sevastian Bondareff
(Signature of Applicant)

_Was brought to this country from Paris by Miller Bros.
101 Ranch. Circus as a Cossack horse trick rider on
Dec 31, 1926 was brought to Laredo Mexico by Mr. Miller
lived in Laredo Mexico until Sept 12, 1927, then crossed
the Rio Grande at Eagle Pass Texas._

Form 659

APPLICATION FOR REGISTRY OF AN ALIEN UNDER AN ACT OF CONGRESS
APPROVED MARCH 2, 1929

#9162/1001-A

REFUGEE R

U. S. DEPARTMENT OF LABOR
AND NATURALIZATION
IMMIGRATION SERVICE

(This application should be carefully studied before preparation and when prepared should be filed either in person or by mail at the immigration office located nearest alien's place of residence.)

| Commissioner of Immigration and Naturalization |

September 1,, 19 34

To Commissioner General of Immigration,
Washington, D. C.

See Previous Correspondence
Bureau File No. *Student*

Through Immigration Officer at **Los Angeles**

Marie Louise Pashgian

SIR: I, the undersigned, an alien, believing that there is no record showing that I am now a lawful permanent resident of the United States, hereby request that, under the provisions of an act of Congress, approved March 2, 1929, a record of registry of my arrival in the United States be made. I hereby agree to appear in person at such time and place as may be designated for examination regarding the claims made by me, and to produce evidence in support thereof. This application is submitted in duplicate with my photograph affixed to each, together with four additional copies of the same photograph, which photographs are 1¾ inches in width by 2¼ inches in length, taken from the same negative, not retouched or mounted, on white background, representing me without hat, showing full front view, and signed (not printed) by me in such a manner as not to obscure my features. I inclose herewith postal money order in the sum of $20, payable to the Commissioner General of Immigration, Washington, D. C. In support of my application I make the following statements:

| Commissioner of Immigration and Naturalization |

THE DATA IMMEDIATELY FOLLOWING ARE GIVEN AS OF THE DATE OF THE ENTRY UPON WHICH I BASE THIS APPLICATION

Name given at birth **Marie** **Pashgian**
(First) (Middle) (Last)

I entered under the name of.......... **Marie** **Pashgian**
(First) (Middle) (Last)

My age was **16** My occupation was **No occupation**
(Yrs.) (Mos.)

I arrived at the port of **Eastport, Idaho** on (date) **June 10, 1928**
(Seaport or land border port) (Month) (Day) (Year)

I {was / was not} inspected and admitted by an immigrant inspector. ~~I came on the vessel~~
(Name of vessel)

(If means of conveyance to the United States was other than by vessel, describe such conveyance)

.......... **I came by automobile.**

RECEIVED
SEP 29 1934
REGISTRY AND

(If entry occurred at other than regular seaport or land border port, describe circumstances of entry (including date) as accurately as possible, naming the State in which, and city or town at or near which, entry was effected

(1)

14—2606

Marie Louise Pashgian
"I have no home or country to return to . . ."

Born in Turkish Armenia in 1904, Marie Louise Pashgian's childhood and family were shattered by religious and ethnic violence. When she was 10, her mother was exiled by the Turkish Government, and Marie was sent to an orphanage. In 1922, the orphanage was closed, and all Armenians were ordered to leave the country. By that time, her mother had been killed, and her father, who had been living in the United States, had died. Marie lived in several more orphanages in Syria until 1927, when she entered Canada using a Lebanese passport. After living in Canada for a year, she drove across the Canadian border to Eastport, Idaho, on June 10, 1928. She settled in Pasadena, California, where she lived with relatives and attended Pasadena Junior College.

In 1934, Marie applied for permanent resident status. Initially, immigration officials moved to deny her this, arguing that because she held a Lebanese passport, she could return there, if deported. Marie believed that she was a refugee because she had been "driven from my home when 9 or 10" and had "no country to return to." On further review, officials ruled in her favor, deciding that since she was a child when she left Armenia, it was likely that the passport was issued only to allow her to escape. Marie Pashgian (later Barsam) became a U.S. citizen in 1937, and lived in the Los Angeles area until she died in 1982.

Opposite: "Application for Registry of an Alien Under an Act of Congress, Approved March 2, 1929," for Marie Louise Pashgian, September 1, 1934
National Archives, Records of the Immigration and Naturalization Service

Below: Supplemental Immigration and Naturalization Service form filed by Marie Louise Pashgian, 1934
National Archives, Records of the Immigration and Naturalization Service

Form 659-A

SUPPLEMENT TO APPLICATION FOR REGISTRY OF AN ALIEN

U.S. DEPARTMENT OF LABOR
IMMIGRATION AND NATURALIZATION SERVICE

(The data called for below should be furnished by aliens who are applying for registry under the Act of June 8, 1934, amending the Act of March 2, 1929, and this form shall be executed and considered as a part of the application Form 659, in such cases.)

Since leaving the country of my nativity, I have resided in each of the following countries, respectively, for the length of time as indicated below:

Country	Province or State	City or Town	From Month : Year	To Month : Year
Syria		Ghazir	1923	1924
Syria		Sidon	1924 July	1927
Canada	B. C.	Nelson	Aug. 1927	June 1928

I believe that I was in the United States prior to July 1, 1933, as a bona fide political or religious refugee for the following reasons: I was driven from my home in Harpoot, Armenia when 9 or 10 years old by the Turks because of my being a Christian, and because of the Political situation created by the war.

I believe that I could not be deported from the United States prior to July 1, 1933, for the following reasons: I have no home or country to return to as the Turkish Govt. does not allow entry, and I would be subject to further religious persecution. Turkey does not recognize me as a citizen.

I hereby acknowledge that I have executed the foregoing as a part of my application for registry on Form 659.

Minezo Araki
"has never returned to Japan"

After the Japanese attack on Pearl Harbor, Hawaii, on December 7, 1941, Minezo Araki, a Japanese fisherman who had been living in the United States for more than 30 years, went from being an alien to being an *enemy* alien. Minezo had come to the United States in 1908, landing in Seattle and working as a farmer and a fisherman off the coast of Southern California. He married Wai Araki, and together they raised her two children from a previous marriage and a daughter from his former marriage.

Even before December 7, as relations between the United States and Japan deteriorated, Japanese aliens were subject to increasing scrutiny by law enforcement and military officials. With such suspicions, the U.S. Navy and Coast Guard boarded Araki's fishing boat, *America*, on November 27, 1941, and searched it for hidden radios and charts. After war broke out, he was evacuated under the Enemy Alien Act to the assembly center in San Pedro, California. On February 4, 1943, he was sent to a camp for Japanese enemy aliens and German prisoners of war near Bismarck, North Dakota. In July 1942, he joined the rest of his family in the internment camp in Poston, Arizona.

When the war turned in favor of the United States, Minezo and his family were allowed to leave Poston in the spring of 1943. They returned to California. Araki remained in the United States until his death in 1965.

Opposite: **Minezo Araki aboard his fishing boat,** *America,* **ca. 1942**
National Archives at Riverside, Records of Naval Districts and Shore Establishments

Below: **Report on boarding of** *America* **by naval inspectors, November 27, 1941**
National Archives at Riverside, Records of Naval Districts and Shore Establishments

```
AMERICA, Commercial Fish Boat          BIO-SP
Co.No. 27 A 726                        CONFIDENTIAL

Subject vessel boarded and inspected by Ensign
Warden, USNR in conjunction with the U.S.Coast
Guard 11-27-41. Operator, Minezo ARAKI, alien-
Jap, 251 A Cannery St., Term.Isl., states that
his wife, Mrs. Wai ARAKI has been registered
owner of subject vessel for 35 yrs.; that he
entered the U.S. at Seattle in 1909 and has
never returned to Japan; that he has fished from
Term.Isl. for 15 years in the area from Newport
Beach to Seal Beach, selling fish to Marine
Cannery, Term.Isl. Only one local chart was
found aboard.
STATISTICAL DATA:      (Verified)

Length: 37', Beam: 8', Draft 18"
Engine: Kermath, 125-HP, Serial No. 25787,G/S
Year Built: 1919
Radio: None
STATISTICAL DATA:      (Not Verified)
Fuel Cons: 3½ gals. per hour
Tonnage: 3½ Tons Net
Speed: 9 Knots
Max Cruis.Rad: 500 miles
Fuel Cap: 240,gals.

    868033/34        CSN, RA          4/22/88

12-16-41 DIO(2),ADIO(2),Cm.NOB(1),File(2)  (J)
```

Michael Pupa
"Parents taken to ghetto in 1942 supposed to be shot"

Opposite: **Michael Pupa, age 13, 1951**

National Archives, Records of the U.S. High Commissioner for Germany

Michael Pupa's family was one of millions destroyed in the Holocaust. Pupa was born in Manyevitz, Poland (now Ukraine), in 1938, and lived there with his parents and sister until 1942. While his refugee case file states that his parents were "taken to ghetto," Michael recalls that he, his parents, and sister lived in Manyevitz until 1942, when his mother and sister were killed there by the Nazis. Pupa, his father, and his uncle Lieb Kaplan escaped. His father was later captured and killed, and Michael and Kaplan spent the next two years hiding from the Nazis in the Polish forests. At the end of World War II, he was smuggled into Germany, where he lived in four different displaced persons camps.

In 1950, his uncle asked that the International Refugee Organization help Michael and his cousin, Broja Meniuk, emigrate to the United States. On May 4, 1951, the two cousins flew to New York City, where they lived for six months in a United Nations home for refugee children. Thirteen-year-old Michael then decided to move to Cleveland, Ohio, where he hoped his uncle could join him and find work. In Cleveland, he was placed with foster parents Edward and Bernice Rosenthal, who raised him along with their children, Cheryl and Allyne, as a part of their family. In 1957, he became a U.S. citizen.

Michael graduated from John Carroll University with a degree in Eastern European history and business. He went into sales and finance and later became the owner of a successful home mortgage company. In 1964, he married Anita Kendis. The couple had two children, Jill and Marc. Today, he and Anita make their home near Cleveland.

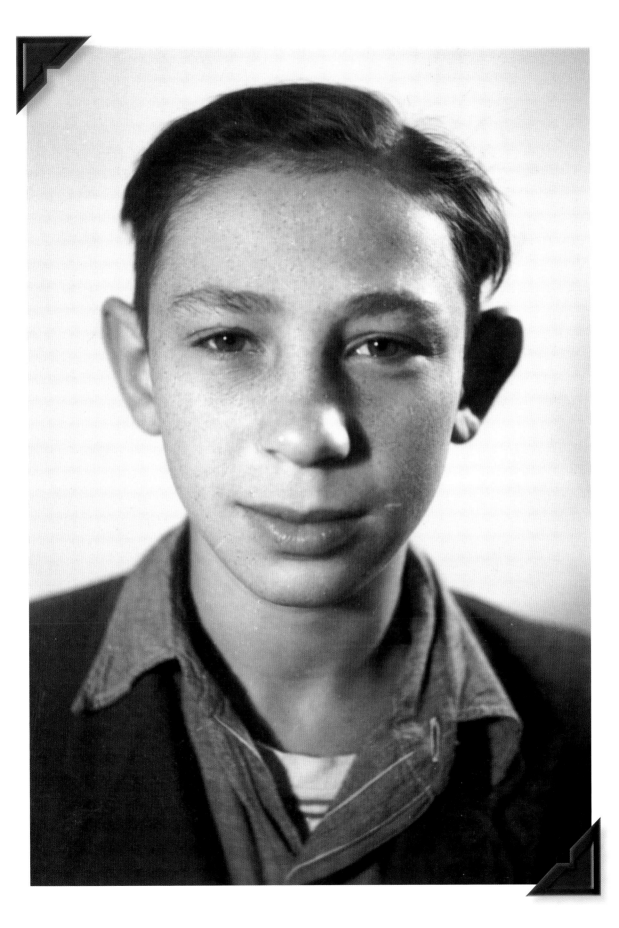

PRE - HEARING - SUMMARY

Prepared ~~for~~ by
International Refugee Organisation Headquarters
~~United States Costs of the A.d.H. Commissioner~~
~~for Germany~~
IRO Children's Village Bad Aibling
for Germany.

Date: 9.1.51.

~~To~~:

~~From~~:

1. Child's Name: PUPA,Michal

2. Date of birth : 2o.8.38 Verified by : Statement in lieu of birth
 certificate made before the
3. Place of birth : Maniewicz,Poland Legal Counsellor ,IRO Area 7
 Verified by : on 3o.11.5o.

4. Present address : IRO CHILDREN'S VILLAGE BAD AIBLING

5. Adult, agency or organization caring for child : International Refugee
 Organisation
 6. Relationship : none

7. Last residence prior to entry into Germany : Maniewicz?Poland

8. Date child brought into Germany : 1946

9. Date child brought into US Zone : April 1946

10. Nationality : Polish 11. Evidence of Nationality : CM 1 Form
 No.58o 965
12. Date of registration by IRO : 10.2.48 (Registered by UNRRA 5.12.1946.)

13. Date and report of Control Center : CM-1 Form No.58o 965 dated 10.2.48

14. Name, address and relationship of nearest blood relatives :

Paternal Step-Uncle Leib Kaplan DP Camp Foehrenwald
 Cousin Meniuk Bronja - IRO Children's Village Bad Aibling

15. Plans expressed by relatives :

 (Parents taken to ghetto in 1942 supposed to be shot)
 Uncle has in writing expressed his wish to have Michal emigrate to USA.

Michael Pupa

Form N-405
UNITED STATES DEPARTMENT OF JUSTICE
IMMIGRATION AND NATURALIZATION SERVICE
(Rev. 2-10-55)

Form approved.
Budget Bureau No. 43-R063.8.

ORIGINAL
(To be retained
by Clerk of Court)

UNITED STATES OF AMERICA
PETITION FOR NATURALIZATION

No. 127977

To the Honorable the ___DISTRICT___ Court of ___UNITED STATES___ at ___CLEVELAND, OHIO___

This petition for naturalization, hereby made and filed, respectfully shows:

(1) My full, true, and correct name is___ MICHAEL PUPA ___
(Full, true name, without abbreviation, and any other name which has been used, must appear here)

(2) My present place of residence is___3369 Cedarbrook Cleveland, Cuya. Ohio___ (3) My occupation is___student___
(Number and street) (City or town) (County) (State)

(4) I am __18__ years old. (5) I was born on ___August 20, 19__ ___, in ___Manelitz Poland___
(Month) (Day) (Year) (City or town) (County, district, province, or state) (Country)

(6) My personal description is as follows: Sex __male__, complexion __fair__, color of eyes __hazel__, color of hair __brown__ height __5__ feet __5½__ inches, weight __134__ pounds, visible distinctive marks __none__; country of which I am a citizen subject, or national ___Poland___ (7) I am ___not___ married; the name of my wife or husband is ___

we were married on ___, at ___
(Month) (Day) (Year) (City or town) (State or country)

he or she was born at ___, on ___
(City or town) (County, district, province, or State) (Country) (Month) (Day) (Year)

and entered the United States at ___ on ___ for permanent residence in the United States
(City or town) (State) (Month) (Day) (Year)

and now resides at ___ and was naturalized on ___
(Number and street) (City or town) (County and State) (Month) (Day) (Year)

at ___ certificate No. ___; or became a citizen by ___
(City or town) (State)

(7a) (If petition is filed under section 319 (a), Immigration and Nationality Act.) I have resided in the United States in marital union with my United States citizen spouse for at least 3 years immediately preceding the date of filing this petition for naturalization, and have been physically present in the United States at least half of that time.

(7b) (If petition is filed under section 319 (b), Immigration and Nationality Act.) My husband or wife is a citizen of the United States, is in the employment of the Government of the United States, or of an American institution of research recognized as such by the Attorney General of the United States, or an American firm or corporation engaged in whole or in part in the development of foreign trade and commerce of the United States, or subsidiary thereof or of a public international organization in which the United States participates; and such husband or wife is regularly stationed abroad in such employment. I intend in good faith upon naturalization to live abroad with my spouse and to resume my residence within the United States immediately upon termination of such employment abroad.

(8) I have __no__ children; and the name, sex, date and place of birth, and present place of residence of each of said children who is living, are as follows:

(9) My lawful admission for permanent residence in the United States was at ___New York___ ___N. Y.___ under the name of
(City or town) (State)

___Michael Pupa___ on ___May 4, 1951___
(Month) (Day) (Year)

on the ___Scandinavian Airlines SE - BDC___
(Name of vessel or other means of conveyance)

(10) Since my lawful admission for permanent residence I have not been absent from the United States, for a period or periods of 6 months or longer, except as follows:

DEPARTED FROM THE UNITED STATES			RETURNED TO THE UNITED STATES		
PORT	DATE (Month, day, year)	VESSEL OR OTHER MEANS OF CONVEYANCE	PORT	DATE (Month, day, year)	VESSEL OR OTHER MEANS OF CONVEYANCE

(11) It is my intention in good faith to become a citizen of the United States and to renounce absolutely and entirely all allegiance and fidelity to any foreign prince, potentate, state, or sovereignty of whom or which at this time I am a subject or citizen. (12) It is my intention to reside permanently in the United States. (13) I am not and have not been for a period of at least 10 years immediately preceding the date of this petition a member of or affiliated with any organization prescribed by the Immigration and Nationality Act or any section, subsidiary, branch affiliate or subdivision thereof nor have I during such period engaged in or performed any of the acts or activities prohibited by that Act. (14) I am able to read, write and speak the English language (unless exempted therefrom). (15) I am, and have been during all the periods required by law, a person of good moral character, attached to the principles of the Constitution of the United States and well disposed to the good order and happiness of the United States. I am willing, if required by law, to bear arms on behalf of the United States, or to perform noncombatant service in the Armed Forces of the United States, or to perform work of national importance under civilian direction (unless exempted therefrom). (16) I have resided continuously in the United States since ___May 4, 1951___ and continuously in the State in which this petition is made
(Month) (Day) (Year)

for the term of 6 months at least immediately preceding the date of this petition and I have been physically present in the United States for at least one-half of the __5__ year period immediately preceding the date of this petition. (17) I have ___not___ heretofore made petition for naturalization:

No. ___ on ___ at ___ in
(Month) (Day) (Year) (City or town) (County) (State)

the ___ Court, and such petition was denied by that Court for the following reasons and causes, to wit:
(Name of court)

(18) Attached hereto and made a part of this, my petition for naturalization, are the affidavits of at least two verifying witnesses required by law.

(19) Wherefore I, your petitioner for naturalization, pray that I may be admitted a citizen of the United States of America, and that my name be changed to

___ I, aforesaid petitioner, do swear (affirm) that I know the contents of this petition for naturalization subscribed by me, and that the same are true to the best of my knowledge and belief, and that this petition is signed by me with my full, true name: SO HELP ME GOD.

ALIEN REGISTRATION NO. ___A8 011 057___

Michael Pupa
(Full, true, and correct signature of petitioner, without abbreviation)

15—41073-7

"Petition for Naturalization" with Oath of Allegiance for Michael Pupa, June 14, 1957

National Archives at Chicago, Records of District Courts of the United States

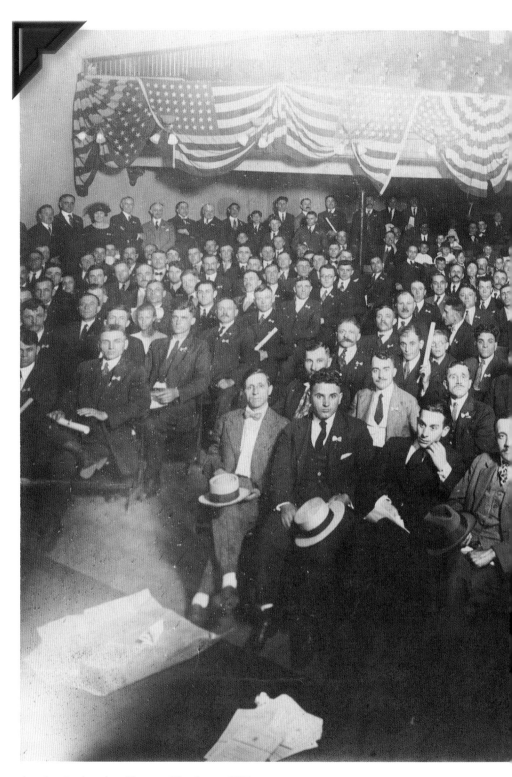

Americanization class, Trenton, New Jersey, 1921
National Archives, Records of the Immigration and Naturalization Service

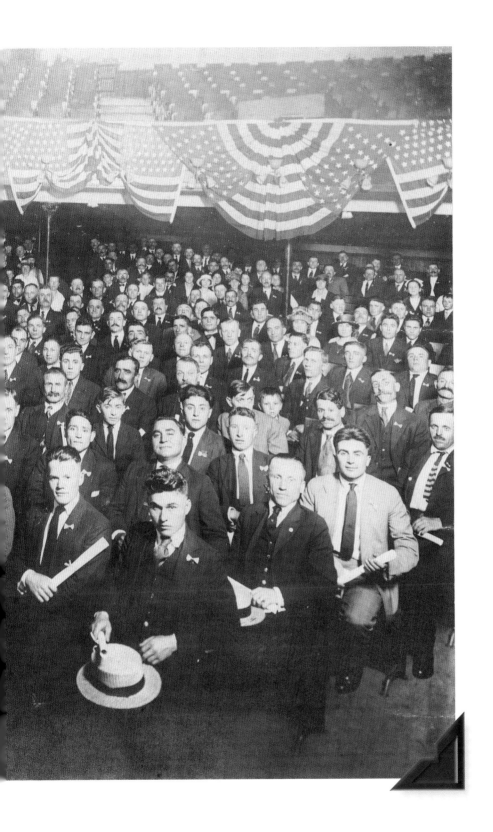

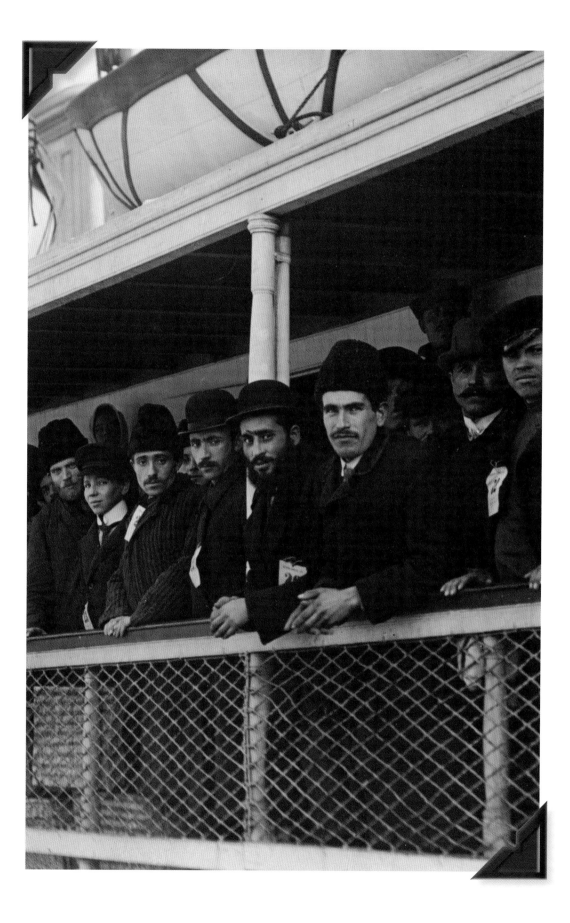

Conclusion

Records of Regulation and Restriction

After World War II, U.S. immigration laws and policies changed. Congress repealed the Chinese Exclusion Act in 1943. The Immigration and Nationality Act of 1952 codified all U.S. immigration law. A 1965 amendment to the 1952 law ended the system of country-based immigration quotas that had been in effect since 1924, and its provisions for family reunification encouraged a surge of immigration from Asia and Latin America. The millions of forms, photographs, interviews, letters, and other records created during the years of restriction—a few of which are reproduced in this publication—now provide a wealth of information for genealogists and historians at the National Archives. In Washington, DC, in 12 regional archives around the country, and online, genealogists can trace their family histories by exploring census schedules, passenger ship arrival records, petitions for citizenship, and immigration case files. Historians also use these records to understand Federal policies, reconstruct immigrant communities, and chronicle efforts at resisting and reforming immigration laws. The personal stories told here are only a few examples among millions waiting to be discovered in your National Archives.

Opposite: **Immigrants on a ferryboat near Ellis Island, ca. 1920 (detail)** *National Archives, Records of the Public Health Service* (90-G-125-6)

Below: **The word "America" in Chinese translates to "beautiful land."**

Acknowledgments

Thinking about the many people who helped produce this publication, and the exhibition upon which it was based, brings to mind lines from the folk song "Somos el barco."

> *The boat we are sailing in*
> *was built by many hands,*
> *And the sea we are sailing on,*
> *it touches every land.*

This project, which deals with people from so many places, was truly a "boat . . . built by many hands." Archivist of the United States David S. Ferriero shared his own family history in his message. The exhibition was created under the direction of James Gardner, Executive for Legislative Archives, Presidential Libraries, and Museum Services; Marvin Pinkert, Director of the Center for the National Archives Experience; and Christina Rudy Smith, Director of Exhibits at the National Archives Building in Washington, DC. James Zeender, Karen Hibbitt, Alexis Hill, and Patrick Kepley served as exhibit registrars. Ray Ruskin designed the exhibition. Brian Barth designed the exhibition catalog, and it was edited by Patty Reinert Mason and Benjamin Guterman. Guterman also edited the exhibition script.

In addition, I am grateful to the following National Archives staff for their expertise and assistance: Anita Andreasian, Rutha Beamon, Hiroko Bledsoe, Terry Boone, Susan Cooper, William Creech, Daniel Dancis, Laura Diachenko, Dorothy Dougherty, Michelle Farnsworth, Jane Fitzgerald, Kathryn Fleming, Gwen Granados, Meg Hacker, Mary Ilario, Susan Karren, Miriam Kleiman, Marisa Louie, Edward McCarter, Sara Pasquerello, Constance Potter, Katherine Orr, Holly Reed, Jennifer Seitz, Martin Tuohy, Annie Wilker, Anne Witty, and Morgan Zinsmeister. My colleagues in the Center for the National Archives Experience—Katherine Chin, Dan Falk, Catherine Farmer, Michael Hussey, Jennifer Johnson, Alice Kamps, Darlene McClurkin, Amanda Perez, and Will Sandoval—were generous with their time and talents.

The Foundation for the National Archives, under the direction of Thora Colot, generously supported the publication of this catalog and the exhibition's marketing. Director of Publications Patty Reinert Mason

managed the catalog project and edited the book. Kathleen Lietzau and Evan Phifer provided administrative and logistical support. Franck Cordes, the Foundation's Director of Administration and Marketing, led the marketing effort.

Outside the National Archives, several skilled and generous historians provided their expertise. Anna Pegler-Gordon of Michigan State University and Marian Smith of the U.S. Bureau of Citizenship and Immigration Services carefully reviewed the exhibition script. Erika Lee of the University of Minnesota and Judy Yung, Professor Emerita at the University of California, Santa Cruz, not only read the script, but uncovered some of the stories featured in the "Attachments" exhibition and catalog in the research for their wonderful book *Angel Island: Immigrant Gateway to America.* Michael Pupa and his family agreed to share the incredible story of his survival and helped me sort out the facts.

As always, Tory Bustard was patient, supportive, and caring.

Finally, I want to acknowledge a little of my own immigrant history. On November 27, 1926, the SS *Transylvania* left Glasgow, Scotland, bound for New York City. On board was my grandmother, Robina Dick Bustard, and her five children, including my father, William Whyte Bustard. Unlike so many of the people in this book, when Robina Bustard and her children arrived in America, they passed through America's gates easily, creating only the briefest mention on the *Transylvania*'s passenger arrival record. My grandmother is listed as a "housewife" in that record, but she would work a number of difficult jobs to support her family through the Great Depression. I keep her photograph next to my graduate school diploma to remind me of the sacrifices she made so that her family could prosper in their new country and so that her grandson could eventually lead his comfortable life. This book is dedicated to her memory.

Robina Dick Bustard from her British passport, 1926

Courtesy of the author

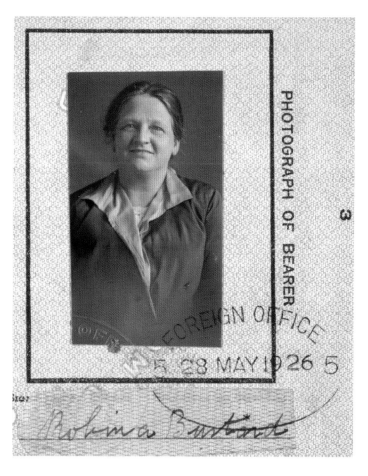

Further Reading

Bodnar, John. *The Transplanted: A History of Immigrants in Urban America.* Bloomington: University of Indiana Press, 1985.

Cannato, Vincent J. *American Passage: The History of Ellis Island.* New York: Harper, 2010.

Daniels, Roger. *Guarding the Golden Door: American Immigration Policy and Immigrants Since 1882.* New York: Hill and Wang, 2004.

Gardner, Martha. *The Qualities of a Citizen: Women, Immigration, and Citizenship, 1870–1965.* Princeton: Princeton University Press, 2005.

Kanstroom, Daniel K. *Deportation Nation: Outsiders in American History.* Cambridge: Harvard University Press, 2007.

Lee, Erika. *At America's Gates: Chinese Immigration During the Exclusion Era, 1882–1943.* Chapel Hill: University of North Carolina Press, 2003.

Lee, Erika and Judy Yung. *Angel Island: Immigrant Gateway to America.* New York: Oxford, 2010.

Motomura, Hiroshi. *Americans in Waiting: The Lost Story of Immigration and Citizenship in the United States.* New York: Oxford University Press, 2007.

Ngai, Mae M. *Impossible Subjects: Illegal Aliens and the Making of Modern America.* Princeton: Princeton University Press, 2004.

Pegler-Gordon, Anna. *In Sight of America: Photography and the Development of U.S. Immigration Policy.* Berkeley: University of California Press, 2009.

Tichenor, Daniel J. *Dividing Lines: The Politics of Immigration Control in America.* Princeton: Princeton University Press, 2002.

Inside back cover: **Immigrant children at Ellis Island, New York, New York, ca. 1908 (detail)**
National Archives, Records of the Public Health Service (90-G-125-29)

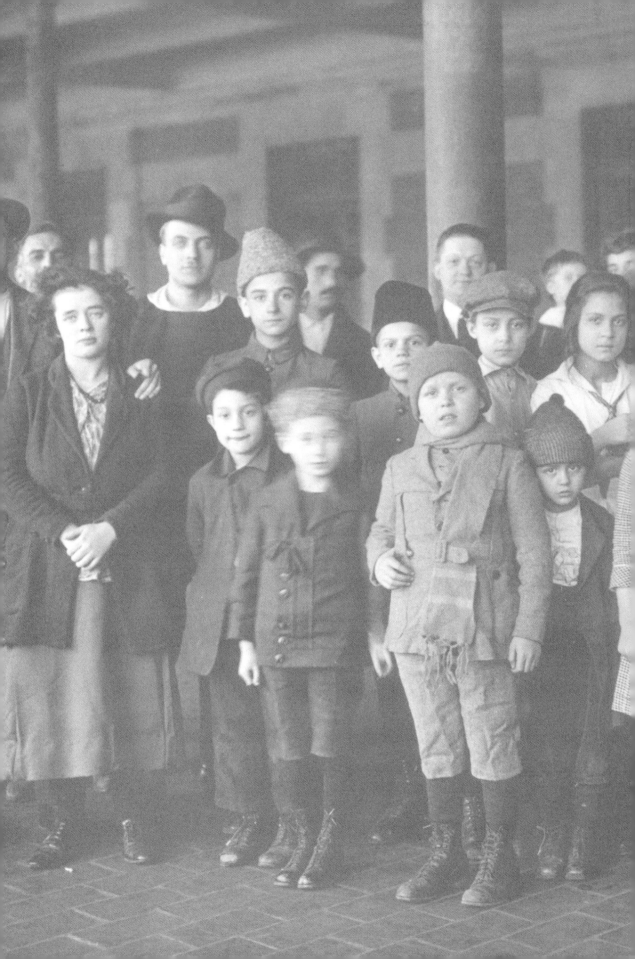